# Anthony Hill

A Retrospective Exhibition

Hayward Gallery
South Bank, London SE1

20 May–10 July 1983

**Arts Council**
OF GREAT BRITAIN

© Arts Council of Great Britain
and the authors 1983

ISBN softback  0 7287 0358 0
      hardback 0 7287 0359 9

Catalogue design: A.D. Design Consultants Ltd.
Exhibition design: Neave Brown
Exhibition administration: Jenny Underwood
Printed by: Oak Tree Press Ltd.

## ACKNOWLEDGEMENTS

Anthony Hill's constructed reliefs, made over a period of thirty years, are an important contribution to a tradition which began with the Russian pioneers at the beginning of this century. We are grateful for the opportunity to present a retrospective selection as part of a series at the Hayward devoted to the work of major British artists. Anthony Hill has been unfailingly helpful throughout the preparation of the exhibition and we have been fortunate to have the collaboration of Dr Alastair Grieve, in the selection and writing, of Neave Brown, who has devised the installation, and of A.D. Design Consultants, who have designed this catalogue. The artist's friends and associates have supported our project from the outset and in this connection we would like to make special mention of Adrian Heath, Dr Michael Morris and Kenneth Powell. Further and essential help has come from the photographers Michael Brandon-Jones and Stella Shackle and from Alison Wardale and Bernadette Wapshott who typed the catalogue manuscript. To everyone who has worked with us, and especially to the many generous lenders, we offer our sincere gratitude.

Joanna Drew
Director of Art

# CONTENTS

**The Development of Anthony Hill's Art from 1950 to the present.**
*Alastair Grieve*

**Documentation**

**Raw Matters**

## THE DEVELOPMENT OF ANTHONY HILL'S ART FROM 1950 TO THE PRESENT
Alastair Grieve

## 1. Collage into Painting, 1950-1952

Anthony Hill was only 21 years old when, during the summer of 1951, he started to play a very active part in the formation of a group of *Constructionist* artists in London.[1] Other members of the group were Victor Pasmore, Kenneth Martin, Mary Martin, Robert Adams and Adrian Heath. They were not a group in the formal sense as they had no title and produced no manifesto, but they did have a great deal in common, indeed more than many formally established 20th century groups. They showed their work together, published their ideas in their own ephemeral publications and they were recognised as forming a cohesive, distinctive nucleus in the London art world by several contemporary critics.[2] Above all they shared a dedication to an abstract art that was non-illusionistic, constructed from basic geometric forms, with dynamic compositions often founded on systems of harmonious proportion such as the Golden Section.

This kind of abstract art attracted little sympathy here in the late 'forties and early 'fifties. The dramatic conversion in 1948 from naturalism to abstract art of Victor Pasmore, who was the group's leader, had shocked critics and patrons previously favourable to his work, and his subsequent move from painting to constructed reliefs in 1951/52 cost him the opportunity of earning his living through his art. With the exception of two of his *Spiral* compositions, no constructed abstract art was shown at any of the official exhibitions at the Festival of Britain. Even a brightly coloured, non-geometric, painterly abstract picture like William Gear's *Autumn Landscape*, one of the prize-winners at the Arts Council's travelling exhibition of commissioned works, *Sixty Paintings for '51*, raised great controversy and was disparagingly compared to patterned linoleum.

So it was for mutual support in the face of indifference or hostility that the *Constructionist* group came together in the summer of 1951 to stage their own exhibitions. The first, *Abstract Painting, Sculptures, Mobiles,* opened in May at the Artists' International Association. It was followed in August by *British Abstract Art* at Gimpel Fils Gallery. In 1952-3 there were three semi-private weekend exhibitions organised by the group in Adrian Heath's studio at 22 Fitzroy Street. In May 1954 an exhibition devoted to the theme of artists' collaboration with the machine was held at the Building Centre. In January 1955 came the exhibition *Nine Abstract Artists* at the Redfern Gallery where the group was joined by three painterly abstract artists, Scott, Hilton and Frost, who had been associated with them in some of their previous exhibitions. Then, in August 1956, *This is To-morrow* was staged at the Whitechapel Gallery with the collaboration of members of the rival Independent Group. Many of these exhibitions were accompanied by publications containing essays by the *Constructionists* and reproductions of their works; for example, *Broadsheet* was first published at the time of the A.I.A. exhibition and the book *Nine Abstract Artists* was published in conjunction with the exhibition of that title.

Though he was much the youngest member of the group Hill played a very active part in all these manifestations. For instance, he was on the organising committee of the A.I.A. exhibition, he, alone, organised the exhibition at Gimpel Fils Gallery in August 1951; wrote the short preface to the catalogue of *Nine Abstract Artists* and co-organised one of the 12 sections at *This is To-morrow*. Hill was able to take up an important position from the beginning because, in a way, he had an advantage over his older colleagues. Unlike them he had no figurative style to slough off. Even his first exhibited work, shown in December 1950 in

an exhibition marking the opening of the Institute of Contemporary Arts' premises in Dover Street, was abstract. Although, or perhaps because, his father was a well-known conventional painter and teacher of traditional methods, Hill escaped any involvement in such art. He achieved this by contact with artists who understood the pioneer abstract movements and had developed from them. A short period at St. Martin's School of Art was unfruitful apart from some lessons from Gerhard Kallmann. So in 1949 Hill moved to the Central School where the Director, William Johnstone, under the influence of Bauhaus ideas, had brought in the "fine artists" Victor Pasmore and Robert Adams to teach students enrolled on design courses. Hill, in the Department of Interior Design, had lessons from both these artists as well as from the Department's Head F.L. Marcus, a German emigré who had been a friend of Gropius, and from Naum Slutzky, another emigré designer who had actually studied at the Bauhaus. Hill had placed himself in the only art school in London, with the possible exception of Camberwell, which could provide teachers informed and enthusiastic about abstract art and Bauhaus design. Pasmore, whom Hill had helped on the cartoon for the ceramic mural, *The Waterfall,* for the Festival of Britain, was working out in his art and theory the problems facing the painter who abandoned mimetic for concrete art. Adams at this time was freeing his sculptures, previously indebted to Moore and Hepworth, of the last traces of figuration. In July 1951 he had his first exhibition of entirely abstract work at Gimpels' and this established him as the only abstract sculptor working in Britain. Hill wrote the introduction to the catalogue. In it he justifies Adams' move and remarks that abstract art alone "offers a means of expression completely in harmony with the techniques of our civilization", an idea which is more applicable to Hill's own work than to

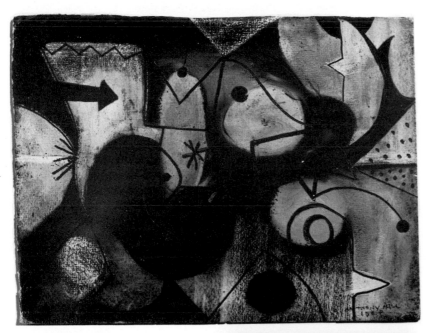

*COMPOSITION*, 1948
Oil and pencil on card
7½ x 10"
(Not exhibited)

*COMPOSITION,* 1950
Oil on plywood with collage
22½ x 13½"
(Not exhibited)

Adams' which was mostly made of carved wood.

Hill's work of 1950-51 shows stylistic links with both Pasmore and Adams, but also with many other artists, for Hill educated himself voraciously by means of contacts both here and abroad. In 1950 he met Kenneth and Mary Martin and Adrian Heath. In the same year he began what were to be regular, annual, visits to Paris where he met Vantongerloo, Kupka, Picabia, Michel Seuphor and Sonia Delaunay among others. He developed an individual interest in the Orphists and also established links with the circle of artists practising geometric abstract art who exhibited at the *Salon des Réalités Nouvelles.* Some introductions were effected by Stephen Gilbert, an English artist resident in Paris, who was to exhibit with the English Constructionists in London from 1954.

Important contacts were made by correspondence and in 1951 Hill started to exchange letters with an extraordinarily disparate triumvirate: Marcel Duchamp, Max Bill, and Charles Biederman. In their respective ways these three artists were to influence him profoundly and the nature of their influence must be considered before we move on to Hill's early works.

Of Duchamp's influence on him, Hill wrote at a later date:

> "at an early and impressionable age I elected Duchamp, in secret, to be a kind of artistic step-father . . . His stand against painting, his innovations and particularly the notion of the ready-made had a profound influence on me. Above all was the idea of putting 'mind' back into art, although for Duchamp this was clearly not the same as having 'rational' content."[3]

More than once Hill has emphasized that it is

5. *COMPOSITION*, 1950
Collage, crayon and gouache
19¾ x 17¼"
K T Powell

Duchamp's *formal* innovations, his use of materials such as glass, metal and kinetic features, which have stimulated him and here the influence can be detected in the constructed reliefs produced from the spring of 1956.

The exchange of letters with Bill centred around an article Hill wrote in 1952 on the Swiss Concrete artist's work and theory. In the article, the first on Bill to be published in an English language journal, Hill stresses Bill's extension of aims established at the Bauhaus: "the reinstatement of the arts in their position as an habitual basis for living, so that they could serve as a framework for a mechanised civilization."[4] Hill also emphasizes the difference between "concrete art" and "abstract art": " 'Concrete art' denotes pure plastic invention, where the work of art exists in its own right, whereas 'abstract art' implies abstraction from something outside of itself." And he quotes an important statement by Bill: "In my opinion it is possible to develop art on the basis of a mathematical way of thought". . .

Hill's awareness of Bill and the ideas of other Zurich Concrete artists such as Richard Lohse[5] led him to become the principal exponent of "concrete art" in London. In the second number of the group's publication *Broadsheet,* which appeared in June 1952, he published *An Introductory Note on Concrete Art* in which he emphasized that the "concrete" art work was an "autonomous organisation" completely free from the figurative tradition. It was not mere pattern making, neither was it "undermined with latent associations" as was much abstract art. It drew on the universal values of science. He extended his explanation in an essay, published in the winter of 1954 in the book *Nine Abstract Artists,* where he defined it as: "a non-mimetic art aiming at an aesthetic of objective invention and sensation, distinctly rational and determinist in contrast to the sub-

jectivist limbo in which the greater part of art is to-day submerged."[6] Lawrence Alloway in his introduction to this book, emphasized that "it is his [Hill's] strategy to extend concrete art by relating it to the whole of art by means of argument. Discourse, like Bill's applied design, spreads the concrete principle over a wider area than art reaches directly." Alloway concluded that Hill's most recent "concrete" works had: "an international flavour, an efficiency nourished on a sound knowledge of non-figurative history and theory."[7]

Given Hill's links with the Zurich School of Concrete artists it is not surprising that he described his own work, up to the mid 'fifties, as "concrete". But since 1952 Kenneth Martin had been using another term — "Constructionist" — and Hill adopted this from 1956. It had been coined by the American artist Charles Biederman to distinguish his constructed reliefs, which he had been making since *c.*1936, from the free standing sculptures of the Russian

*3 SECOND PAINTING*, 1949
Red on black
12 x 16"
Brenda Beaghen
(Not exhibited)

1. *FRAME AND STRING
   CONSTRUCTION*
   14 x 11¾ x 1"

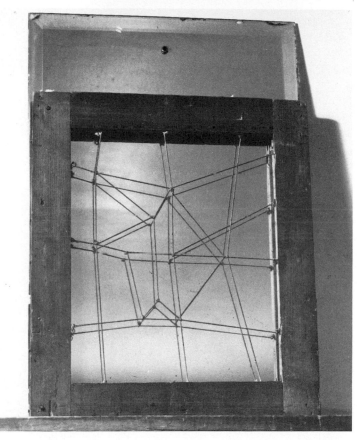

Constructivists. Biederman's book *Art as the Evolution of Visual Knowledge*, an idiosyncratic history of world art, and his shorter *Letters on the New Art*, which explained the theory behind his constructed reliefs, were discovered by the English group in 1951. At the end of this year Hill wrote to the author to obtain information for an article on his art and theory.[8] At this time in London it was difficult to find information on the pioneer abstract movements and almost impossible to see the works themselves. Adrian Heath has recalled that the group were very excited to see a Mondrian, a work of 1927, at an exhibition of *L'Ecole de Paris* at the Royal Academy early in 1951 but this was a rarity. *Art as the Evolution of Visual Knowledge*, supplemented by the recently published Wittenborn, Schultz editions of the writings of Mondrian, Arp and Vantongerloo, provided a marvellous quarry of reproductions and information on De Stijl, Constructivist and Constructionist art. Hill was impressed by Biederman's belief that painting was dead and that the future of art lay in developing orthogonal reliefs constructed from machine age materials. Biederman's influence, like that of Duchamp, was to become more important with the move into relief constructions in 1956 but in the early '50s Hill's concern for an art that was planned before it was executed was reinforced by Biederman's forthright condemnation of Surrealism, Tachisme, and Abstract Expressionism. They found in correspondence that they shared an indebtedness to Korzybski's *Science and Sanity* which stresses the need for mathematical order, building on the discoveries of the past rather than destroying them and the importance of asymmetry in heightening our awareness of order and structure.

But Hill and Biederman also found that they differed profoundly on many points and primarily over the question of abstraction. Biederman insisted that the artist had to

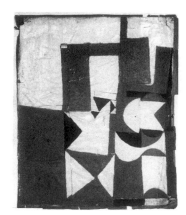

8. Collage of *JEUX*, 1951
   Ripolin, oil, tape, collage
   30½ x 25¼"

9. *JEUX*, 1951
   Ripolin on cardboard
   30 x 25¼"

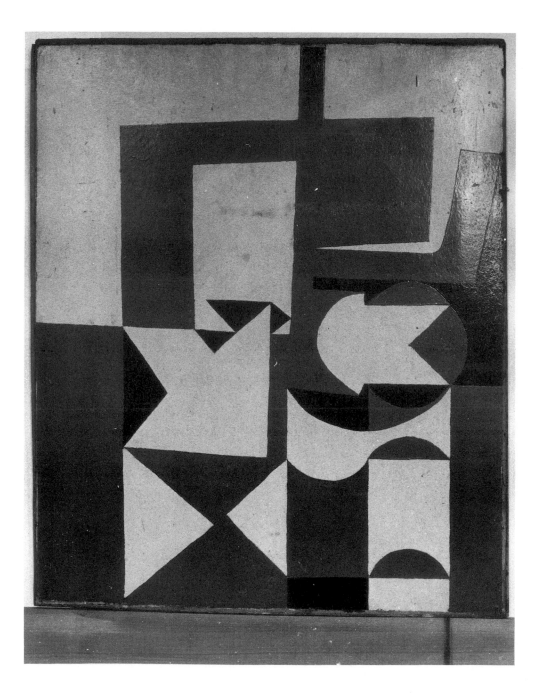

11. *COMPOSITION*, 1951
Ripolin over collage on
cardboard
20 x 15¾"

abstract from nature's structural processes while Hill, agreeing with Bill and Pasmore and his other English colleagues, believed that the "concrete" work of art stood apart from any abstracting process. Later, when Hill moved into relief, the differences were exacerbated for while Biederman insisted on the use of nature's prismatic colour and sprayed his aluminium reliefs with paint, Hill restricted himself to unpainted industrial materials which were predominantly in black, white and greys.

Hill's earliest works, however, show the influence of artists such as Klee, Miro, Nicholson and, above all, the Cubists. The oil and collage composition shown at the I.C.A. in December 1950, for instance, has a stepped 'T' shaped motif which occurs in several other works of this time and which derives from a Cubist collage *(Tête)* by Picasso belonging to Roland Penrose. The influence of Gris, who became known through Kahnweiler's book of 1947, can be seen in other collage and mixed media works of 1950 (e.g. no. 5). Flat compositions of swinging, interconnected loops, zig-zags, stripes, tilted squares and triangles are played off against the vertical and horizontal boundaries of the works. Segments of circles, adapted in many cases from a Pears Soap label with an oval motif, are interwoven and wrapped around rectangular units. There is at this time a strong interest in matière, paint and other materials are massaged into the surface, areas are rubbed and scraped. There are also experiments with *Tachiste* paintings done as rapidly as possible ("Three second paintings"); and these rare flirtations with free painting continued until surprisingly late; one such work, of 1953, is reproduced in *Nine Abstract Artists*. Unique amongst these early works is a construction of taut lengths of string threaded across a rectangular wooden frame and knotted into an irregular diaper of triangles and quadrilaterals (No. 1). With its web of inter-

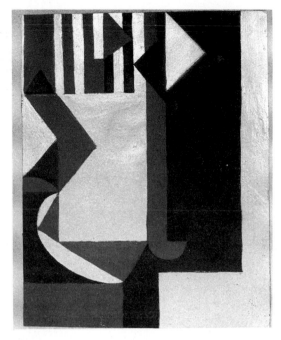

dependent nodes and branches, this string construction, evidently made before 1950, prefigures in an extraordinary way Hill's work after *c.* 1965.

The first mature works, *Jeux, Composition* (no. 11), *Intervals* and *Toccata*, were made in 1951. They have flat, clear-cut compositions of dynamically placed geometric shapes. Positive and negative spaces are carefully balanced. Preliminary versions were made in collage which was then overpainted or used as a model for a painted version. Hill used an enamel paint (ripolin) which forms opaque and shiny surfaces like those of commercial signs. Probably under the inspiration of Moholy-Nagy's "Telephone" paintings, Hill hoped to have them reproduced mechanically. (In 1952 *Jeux* was titled *Prototype for Commercial Reproduction* when exhibited in the exhibition *Mirror and Square*.) These paintings are unlike anything else being produced in England, even

*PAINTING, RED AND WHITE,*
1952
Oil (sign painter's paint)
on canvas
36 x 36"
Calouste Gulbenkian Foundation
(Not exhibited)

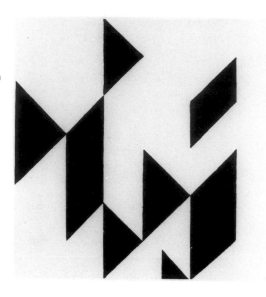

13. *TOCCATA,* 1961
Linoleum, oil, ripolin on board
18 x 14"

by other members of the Constructionist group, and they relate more easily to the early works of Vasarely and of now forgotten artists who showed at the *Salon des Réalités Nouvelles.* This Salon, founded by Del Marle in 1946, was devoted to geometric abstract art. Not only was there a Salon exhibition each year but also an annual publication of an Album of reproductions of works exhibited or related in style. Hill's *Composition 1951,* was reproduced in the Fifth Album of June 1951 and he exhibited *Jeux* in the Salon of 1952 (under the title *Study for a work in progress*).

In the pictures of 1951 Hill has turned his back on worked-up matière. Layers of ripolin have been applied to give unmodelled surfaces. In *Intervals* and *Toccata* the complete avoidance of illusionist depth is further emphasized by the nailing to the surface of squares of linoleum. Colours are now limited and strong, orange, red-brown, black and white, and shapes are more restricted and less individualised than they had been in earlier works. This development is continued in the last paintings to use colour which were made in 1952. For example, *Painting: Red and White* of this year is made from thickly applied sign-writers' paint. Red triangles and parallelograms, formed by a net of verticals and diagonals, join with the white to make a positive/negative composition over the entire surface. By severely reducing form and colour Hill aimed at a clear visual statement. He developed this aim more fully in the black and white works of 1953 to 1956.

## 1. Collage into Painting, 1950-1952 Exhibition List

1. *FRAME AND STRING CONSTRUCTION*
14 x 11¾ x 1"

2. *COMPOSITION,* 1950
Oil and pencil on cardboard
9½ x 12¾"
Brenda Beaghen

3. *COMPOSITION,* 1950
Collage 13½ x 19"
Leicester Education Committee
The Leicestershire Collection
for Schools and Colleges

4. *COMPOSITION,* 1950
Collage and oil on paper
27¾ x 20¾"

5. *COMPOSITION,* 1950
Collage, crayon and gouache
19¾ x 17¼"
K T Powell

6. *COMPOSITION,* 1951
Pencil and collage
23¼ x 18"
Adrian Heath

7. *COMPOSITION,* 1951
Pencil on shelf paper
24 x 17¾"

8. Collage of *JEUX,* 1951
Ripolin, oil, tape, collage
30½ x 24¼"

9. *JEUX,* 1951
Ripolin on cardboard
30 x 25¼"

10. Repaint of *JEUX* (by Clio Heath), 1982
30 x 25¼"

11. *COMPOSITION,* 1951
Ripolin over collage on cardboard, 20 x 15¾"

12. *INTERVALS,* 1951
Linoleum, distemper on board
29½ x 24¾"

13. *TOCCATA,* 1951
Linoleum, oil, ripolin on board
18 x 14"

*UNTITLED*
Oil on canvas
A. 7 x 6¾"
B. 7½ x 9¾"
(Not exhibited)

*UNTITLED c.*1948-49
Pencil on oil on canvas
A. 13¼ x 12¼"
B. 7¾ x 5¾"
C. 7¼ x 6"
D. 7¾ x 5½"
(Not exhibited)

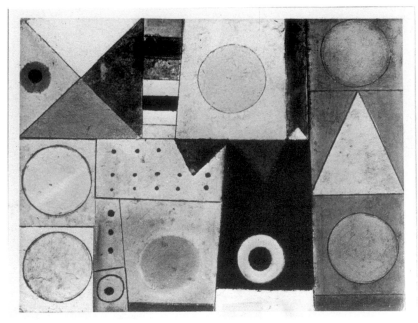

2. *COMPOSITION*, 1950
Oil and pencil on cardboard
9½ x 12¾"
Brenda Beaghen

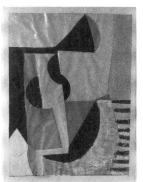

3. *COMPOSITION*, 1950
Collage
13½ x 19"
Leicester Education Committee
The Leicestershire Collection
for Schools and Colleges

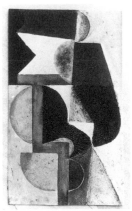

*COMPOSITION*, 1950
Collage, oil, etc on cardboard
19½ x 10½"
(Not exhibited)

4. *COMPOSITION*, 1950
Collage and oil on paper
27¾ x 20¾"

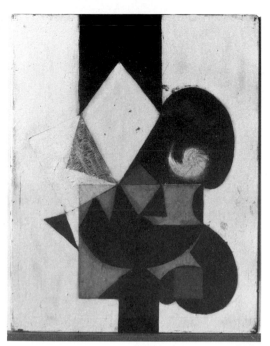

*FREE ORTHOGONAL
COMPOSITION*, 1953
Oil
49 x 38″ (destroyed)

*PROJECT*, 1950
Oil and collage on board
18 x 14″
(Not exhibited)

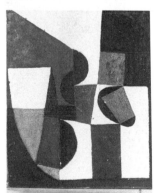

*COMPOSITION*, 1950
Collage, carbon paper and oil
26¾ x 22¼″
(Not exhibited)

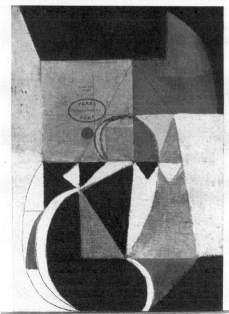

*UNTITLED*, 1950
Oil on canvas with collage
21¼ x 14½″
(Not exhibited)

12. *INTERVALS,* 1951
   Linoleum, distemper on board
   29½ x 24¾"

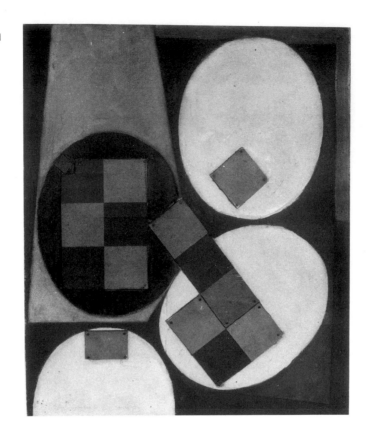

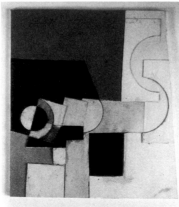

*UNTITLED*
Collage, 11⅜ x 10¼"
(with slanting edge)
Private Collection
(Not exhibited)

14. *LOOP-LINE,* 1953
Photoprint
20 x 16"

## 2. Black and White; the first reliefs, the last paintings, 1953-56

Between 1953 and 1956 Hill worked exclusively in black and white. After his strongly coloured works of 1951-2 the change comes as a shock although there had been some works already in 1950-51 with a very restricted colour range; a collage and paint composition of this date in black, white and grey survives in a damaged state and is reproduced in *Nine Abstract Artists* (pl. 21). Other members of the Constructionist group had already renounced colour in some, if not all, of their works. Some of Pasmore's last *Spiral* compositions of 1950-51, the *Waterfall* mural amongst them, are black and white, as are some of Kenneth Martin's paintings and earliest mobiles of 1951-2. Mary Martin's reliefs, started in 1951, are all white or grey until 1954-5 when she introduced materials such as black plastic, hardboard and stainless steel.

15. *LOOP-LINE* (Study), 1953
Black ink
20½ x 16¼"

Hill associated colour with qualities he was trying to avoid, decorativeness, wilfulness, indecisiveness. Black and white works were also easier than coloured works to have made in multiples by mechanical means and this idea interested him strongly, as it did Biederman and Pasmore. *Loopline,* a photographically reproduced single line drawing of 1953, is an example which was used by Alloway to illustrate an article on the Constructionist group published in January of the following year. Here Alloway wrote: "Anthony Hill, like Pasmore, is aware of the challenge of 20th century serial production, which replaces the uniqueness of the work of art with an aesthetic of the typical. Hill has designed projects for limited mass-production, photostats of a mathematically governed linear structure."[9]

In *Loopline* rhythmically expanding curves contrast with dynamic acute and 90° angles and in two versions of the print some areas are

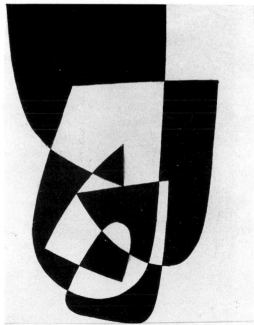

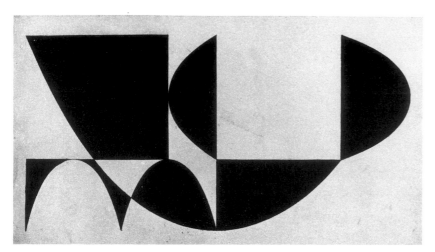

18. viii Study for
*CATENARY RHYTHMS,*
1953-4
Collage on paper
11¾ x 21½"

filled in to make a positive/negative pattern. We see this finely balanced contrast of curved and angular forms and areas of black and white carried out much more ambitiously in *Catenary Rhythms*. The first version of this was started in 1952 but soon destroyed; the next, developed with a small grant from the I.C.A., was shown at an exhibition designed to demonstrate how artists could use machine technology; it was organised by Kenneth Martin, Adams, Pasmore and the architect John Weeks at the Building Centre in the summer of 1954. This second version measured 3' 5" x 6' 10", a double square. Many preliminary studies survive in which we see Hill experimenting, as did other members of the group, with root rectangles which he combined with approximate catenary curves. Different balances of white, black and also grey areas were tried out. Once the composition was established he enlisted the help of a structural engineer to draw out the correct catenary curves. The engineer's drawing was then photographed and made into an enlarged dye-line print which was painted over in ripolin and mounted on a sheet of backed cardboard. Hill had hoped to have a version executed in screen-printed enamel on metal but this was not done and the version shown at the Building

Centre was destroyed after the exhibition. A third version has been made for this Arts Council's exhibition.

As yet Hill had made no relief constructions despite his friendship with Pasmore and his already extensive correspondence with Biederman, but he had hoped to have one ready for the Building Centre exhibition. This relief, *Progression of Rectangles,* was based on a series of paintings started in 1953 and was eventually shown at the exhibition *Nine Abstract Artists* in January 1955. Most of Hill's work has an approximate bilateral symmetry around a vertical axis but here the sequence of rectangles expand from left to right along a central horizontal axis. The progression is not an obvious one, a straight line or segment of a circle cannot be drawn through all the points, and it stops short of the right side. The theme of the Building Centre exhibition possibly encouraged Hill to investigate the use of sheet plastics now, as it did his friend Adrian Heath who showed a plastic *Light Screen* at the exhibition which has similarities to *Progression of Rectangles,* but as yet Hill is not exploiting the effects of light and shadow made by projecting planes and the relief depends very closely on the paintings which preceded it. The rectangles of black and white opaque plastic are mounted flat onto a plane of transparent plastic which is held by distancing pegs above a base panel.

Hill continued to produce paintings until early in 1956 while experimenting with further reliefs. We find the same concerns in both, the use of simple geometric forms and clear-cut divisions of black and white areas composed to achieve an overall balance. More crucial than before seems the idea of a central axis with simple forms balanced asymmetrically around it and Hermann Weyl's famous book *Symmetry,* which appeared in 1952, may be an influence here. Hill continues to exploit his early interest

20. *PROGRESSION OF RECTANGLES*
   (relief construction), 1954
   Plastic on board, 36 x 36 x 3"
   (Photo: Adrian Flowers)

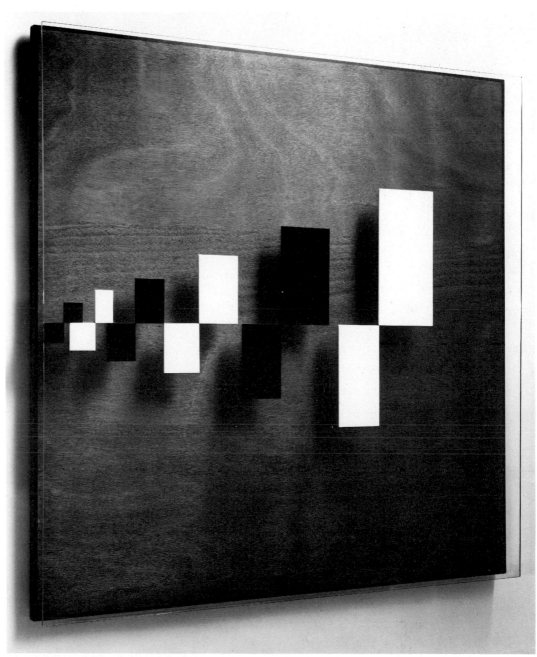

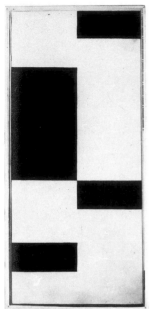

21. *ORTHOGONAL
COMPOSITION*, 1954
Oil on canvas, 54 x 24"
K T Powell

23. i. *BLACK POLYGONS*, 1954-5
Ripolin on board, 60 x 50"

in contrasting textural effects with varying degrees of light absorption, and juxtaposes shiny, matt, smooth and rough surfaces in both paintings and reliefs.

The concern with balance around a central, vertical axis is very evident in *Orthogonal Composition,* painted in the summer of 1954, which is the first of a series of tall, narrow canvases continuing into the New Year of 1956. Simple positive/negative elements are counterbalanced with extreme clarity. The large black rectangle is four times the size of the other rectangles which are all of the same size. Lawrence Alloway suggested in *Nine Abstract Artists,* where the picture was the most recent to be reproduced, that the composition had "a mathematical basis"[10] but this does not seem to be so. Hill himself was curious about it and in December 1955, over a year after it was finished, made a smaller "standardised version" in shallow relief using root rectangles. He found he preferred the first version which he had designed without calculation.

Hill does use geometric calculation in other works of 1954-5. *Black Polygons,* two versions of which were made at this time, is an example. It is a large work painted in ripolin on plywood and was originally planned for a screen which Hill hoped to have made of enamel. Each polygon has ten sides of regularly decreasing lengths and each has one right-angle. The sides of the larger polygon are twice the length of the sides of the smaller. (Top polygon 2", 4", 6", 8", 10", 12", etc. Bottom polygon 1", 2", 3", 4", 5", 6", etc.) The low relief of black and white plastic sheet called *Cut in a Continuum* is another example. It was inspired initially by the net of a cuboctahedron but the composition underwent many variations before Hill was satisfied with the balance of squares and equal-sided triangles.

The Tate Gallery's *Orthogonal/Diagonal*

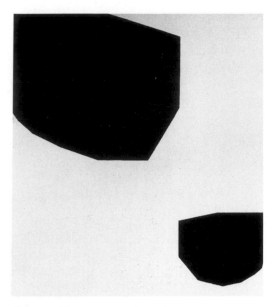

*Composition* seems to have been "programmed" by the joining of points of a right-angular grid orthogonally and diagonally and superimposing the nets. Unlike any work to date (1954) the composition is symmetrically balanced, it is a double square, but it is not, strangely, visually balanced and restful. Hill was aware of its ambiguities and wrote about them much later:

> "the linear structure is optically unstable at the interior junctions and this is deliberate. The composition can be 'read' in a number of different ways. In terms of continuous lines one can see it as comprising 26 lines . . . Again one can choose to see 17 nodal points . . . In terms of areas one sees 4 squares and 16 triangles. Van Doesburg and Max Bill were influences, but so was Duchamp in that the composition was a 'geometric readymade'."[11]

It is interesting that the influence of the "artistic stepfather" of Hill's early works should persist, and manifest itself in surprising ways.

24. *ORTHOGONAL/DIAGONAL COMPOSITION*, 1954
Oil and enamel on canvas,
23 13/16 x 47 15/16"
The Trustees of the
Tate Gallery

26. *DIPTYCH I*, July 1955
Plastic and board,
23½ x 24 x 1"

*Orthogonal/Diagonal Composition* is Hill's first "line" painting. The black lines were painted with matt black-board paint, the white areas with shiny enamel. Two half-size versions were made afterwards, one with enamel paint and the other matt paint, and with lines of different thicknesses. These variations in size, texture and detailing indicate that aesthetic effects not immediately dependent on mathematical relationships continued to be important for Hill.

The relief *Diptych I*, made in July 1955, is a startling, though logical, development of the use of black lines, or rather thin bands, to articulate rectangular white planes. The square format is cut down the centre by an open channel and the halves are balanced asymmetrically by two slots of equal length cut into their sides. The white planes are of light-reflecting plastic while the panel base seen through the cuts is matt black.

With *Diptych I* Hill succeeded in making a harmonious, asymmetrically balanced composition by minimal yet subtle means. As was his habit by now, he methodically consolidated and carried forward his discoveries in subsequent works. During the winter of 1955-6, for instance, he painted four, tall, narrow canvases, in enamel and oil paints, which presented further variations on the theme of asymmetric balance. A contemporary photograph, showing three of these canvases hanging in Hill's studio in Greek Street with his experimental reliefs of the period stacked below

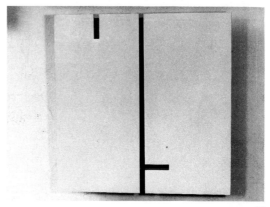

21

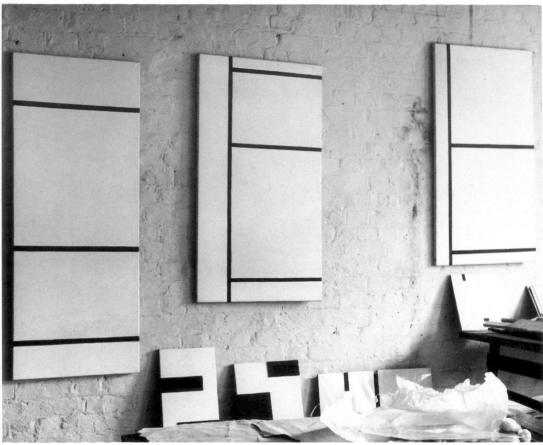

them, emphasizes the very radical nature of his art at this time. It is true that Hilton and Scott had produced a few austere black and white line paintings in 1953-4 but these have figurative connotations which are emphatically lacking in Hill's works. His last paintings of 1955-6 are better placed in the tradition established by Mondrian, Vantongerloo and Bill. They embody harmony, order, balance, in the turbulence of the modern world. Hill was impressed by the Mondrian exhibition at the Whitechapel Gallery in 1955. He had talked with Vantongerloo in Paris and, as we have seen, corresponded with Bill. But despite these established links with the Continental Masters, Hill's last pictures are not derivative. They state very clearly that harmony can be created by a few elements held in asymmetric balance and they demand of the eye a sensitivity to subtle variations in proportion, texture and tone. A passage from Korzybski is appropriate: "asymmetrical relations include many of the most important ones. They are involved in all *order*, all *series*, all *function*, in 'space', in 'time', in 'greater' and 'less', 'more' and 'less', 'whole' and 'part', 'infinity', 'space time'." Hill's last paintings make us acutely aware of these relations.

**2. Black and White; the first reliefs, the last paintings, 1953-56 Exhibition List**

14. *LOOP-LINE*, 1953
Photoprint
20 x 16"

15. *LOOP-LINE* (Study), 1953
Black ink
20½ x 16¼"

16. *LOOP-LINE* (Study), 1953
Black ink
26 x 18¼"

17. *CATENARY RHYTHMS*, 1953-4 (this version made by Richard Plank, 1982)
Paint over dye-line print
Original version 41 x 82".
This version 2' x 4'

18. Studies for *CATENARY RHYTHMS*, 1953-4

 i)  Ripolin, pencil, biro, pen
 3¼ x 7¼"
 The Trustees of the British Museum (1978. 10.7.16)

 ii) Biro
 3¼ x 4¼"
 With a photograph of the finished work and two photographs of it *in situ* at the Building Centre in 1954.
 The Trustees of the British Museum (1978. 10.7.17)

 iii) Ripolin, oil, gouache
 6½ x 12¾"
 The Trustees of the British Museum (1978. 10.7.19)

 iv) Crayon, pencil, pen, biro
 6¼ x 12¾"
 The Trustees of the British Museum (1978. 10.7.21)

 v) Pencil, gouache
 10¾ x 7½"
 The Trustees of the British Museum (1978. 10.7.24)

 vi) Ripolin, gouache
 9½ x 7½"
 The Trustees of the British Museum (1978. 10.7.25)

 vii) Pencil, ink
 12 x 21½"

 viii) Collage on paper
 11¾ x 21½"

 ix) Pencil on tracing-paper
 12 x 21¾"

19. *PROGRESSION OF RECTANGLES*, 1953
Emulsion (housepaint) on canvas, 36 x 36"

20. *PROGRESSION OF RECTANGLES* (relief construction), 1954
Plastic on board, 36 x 36 x 3"
Adrian Flowers

21. *ORTHOGONAL COMPOSITION*, 1954
Oil on canvas, 54 x 24"
K T Powell

22. *CUT IN A CONTINUUM (low relief)*, 1955-6
Plastic on board
36 x 24½ x ¼"
The Trustees of the Tate Gallery

 Studies for No.22

 i) Collage on perspex sheet
 11 x 5⁵⁄₁₆"

 ii) Collage on paper
 10¹³⁄₁₆ x 5⁵⁄₁₆"
 Victoria and Albert Museum

23. i. *BLACK POLYGONS*
 1954-5
 Ripolin on board
 60 x 50"

 ii. *BLACK POLYGONS*
 1954-83 (new version by Richard Plank)

24. *ORTHOGONAL/DIAGONAL COMPOSITION*, 1954
Oil and enamel on canvas
23¹³⁄₁₆ x 47¹⁵⁄₁₆"
The Trustees of the Tate Gallery

25. *COMPOSITION*, 1955-6
Oil and ripolin on canvas
50 x 19¾"
Private Collection

26. *DIPTYCH I*, July 1955
Plastic and board
23½ x 24 x 1"

27. *DIPTYCH II*, January 1957
Plastic and brass (painted black), 23½ x 24 x 1¼"

28. *PAINTING, BLACK AND WHITE*, 1955-6
Ripolin and oil on canvas
50 x 20"
The Trustees of the Tate Gallery

29. *PAINTING, BLACK AND WHITE*, 1955-6
Oil on canvas, 41¼ x 22¾"

30. *PAINTING, BLACK AND WHITE*, 1955-6
Ripolin and oil on canvas
41 x 22½"
Private Collection

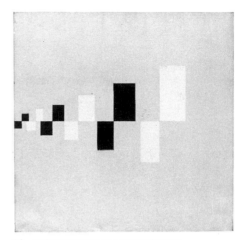

19. *PROGRESSION OF RECTANGLES*, 1953
Emulsion (housepaint) on canvas, 36 x 36"

18. ix
Study for *CATENARY RHYTHMS*, 1953-4
Pencil, ink
12 x 21½"

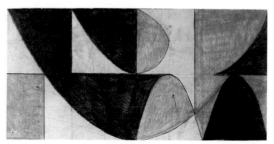

18. iv
Crayon, pencil, pen, biro
6¼ x 12¾"
The Trustees of the British Museum

*LOW RELIEF, (Cut in a Continuum)*, 1955
Plastic, 34 x 17 x ¼"
McCrory Foundation
(Not exhibited)

28. *PAINTING, BLACK AND WHITE*,
1955-6
Ripolin and oil on canvas,
50 x 20"
The Trustees of the
Tate Gallery

### 3. The Orthogonal Reliefs; colour in the materials, real light and space, 1956-1963

Dating from the New Year of 1956, contemporary with Hill's last paintings, are a group of experimental reliefs made from vertical bands of contrasting materials such as transparent and opaque plastic sheet, rubberized cloth, tape, matt and shiny paint. Like the earlier reliefs, *Progression of Rectangles, Cut in a Continuum* and *Diptych I,* they are closely related to the paintings. But in the spring of this year Hill started to use deeper relief elements for which there was no equivalent in paint. No more paintings were made after this date.

Light is of course of great importance in the constructed reliefs. The projecting elements throw shadows of varying intensity onto the larger planes on which they are mounted. The materials are closely related to their shadows as they are tonal, uncoloured. Following his experiments with contrasting textures and the light absorbing qualities of different surfaces Hill was able to combine synthetic materials with assurance and subtlety — white or transparent plastic sheet, black plastic angle, silver grey or black anodised aluminium. Sometimes more "exotic" materials were used: in July 1956 he started to use copper sheet and in the summer of 1959 he made a group of reliefs with white stove-enamelled iron backs. Occasionally he used brass angle, zinc and stainless steel. These materials were always left in the state they arrived from the manufacturers and there is a Duchampian element of the "ready-made" in their selection. One of Hill's most important "finds" in the spring of 1956 was "L" shaped aluminium angle measuring 1" x 1" x ⅛" and this is used in the majority of his orthogonal constructed reliefs.

All the reliefs up to 1961 are orthogonal. Materials are assembled in horizontal/vertical formations with an emphatic vertical axis. Base planes or plastic of metal sheet are mounted proud of, and parallel to, the wall on which they are hung and as there are no frames, they cast their shadows direct onto the wall and become part of the environment in which they are placed. As before, asymmetric balance is crucial and this must be why Hill was so attracted to the "L" shaped angle which has a transformational but not bilateral symmetry. Even when he places such a piece of metal angle down the centre of a square plane, as he does in no. 38, the overall format is subtly unbalanced. Only in one case, the Tate's *Constructed Relief* of December 1956, has he used bilateral symmetry.

Hill first showed constructed reliefs in August 1956 at the exhibition *This is To-morrow.* The aim of this exhibition was to demonstrate how small groups of artists and architects could fruitfully collaborate and was rather an anarchic

40. *RELIEF CONSTRUCTION,*
1956
Copper, aluminium, plastic,
22½ x 15½ x 2¼"

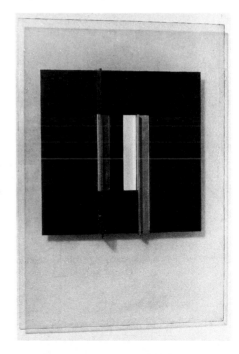

response to the ideas of total integration of the arts suggested by the French *Groupe Espace,* of which Stephen Gilbert was a member. In the catalogue Hill published his first exposition of the constructed relief. He saw it as "an independent art form" to be valued for its own sake, which nevertheless "contains aspects of architecture in itself . . . heightened to a degree hitherto impossible. . . It is an art that deals with carefully ordered visual stimuli, and in so doing, trains and conditions responses to these stimuli."[12] He published several subsequent expositions which can only be briefly referred to here. For example, in the catalogue of an exhibition in the New Year of 1957 titled *Statements — a review of British abstract art in 1956* (where Hill showed a version of no. 31), he wrote:

"Synthetic materials and other materials like glass and metal in their machine states give the abstract artist a new and important group of media and it is with these materials that 'Constructionist' conceptions can be realized and developed. With these new materials comes a new 'art object' — the construction. . . Constructionist art is purely inventive and concerned with manipulating real entities; it is neither Academic nor Phantasist, Classical or Romantic, it is Realist."[13]

And in 1960 he wrote in the journal *Structure:*

"A constructional relief neither stands like sculpture nor is it suspended like mobiles and other kinds of constructions, it is not a window or carpet like a painting and neither is it part of the wall.

The relief is the real plastic object par excellence, it has the dimensions of everyday objects and yet it is not to be confused with them."[14]

Hill was not of course the first of the English Constructionist group to abandon painting for reliefs. Both Pasmore and Mary Martin had done this towards the end of 1951. Pasmore used plastic, aluminium and painted plywood in his early reliefs and by 1953 was assembling prefabricated planes in vertical, orthogonal clusters. He was acutely concerned with asymmetric balance and from the summer of 1954 produced a series of reliefs with subtly modulated planes grouped around central, vertical axes. Some of his reliefs are black and white while in the majority subdued colour is used. He usually used paint and only on rare occasions did he restrict himself entirely to industrial materials with inherent colours.[15] While being related to Pasmore's reliefs, Hill's are further removed from painting and show a greater enthusiasm for the "ready-made", synthetic, contemporary materials of our industrial culture. In this respect he has something in common with Kenneth Martin who used commercial stock brass for his screwmobiles from 1953.

Mary Martin only started to use plastic and other synthetic materials late in 1954. In her previous work she had used plaster or various kinds of painted wood. But even her reliefs constructed from synthetic materials with inherent colours have very little in common with Hill's. Although, like him, she was concerned with asymmetric balance and vertical and horizontal orientation of planes, which she connected with the basic form of our bodies and of the architecture in which we live, her treatment of space is quite different as it is always systematically developed in a shallow layer between a base and surface plane.

As well as Pasmore and Mary Martin there was another relief maker besides Hill amongst the English Constructionists by the mid-'fifties. This was John Ernest who had met Pasmore in

46. *RELIEF CONSTRUCTION,*
June-July 1959
Plastic, aluminium,
on enamelled stove-back
16 x 17 x 2¼"

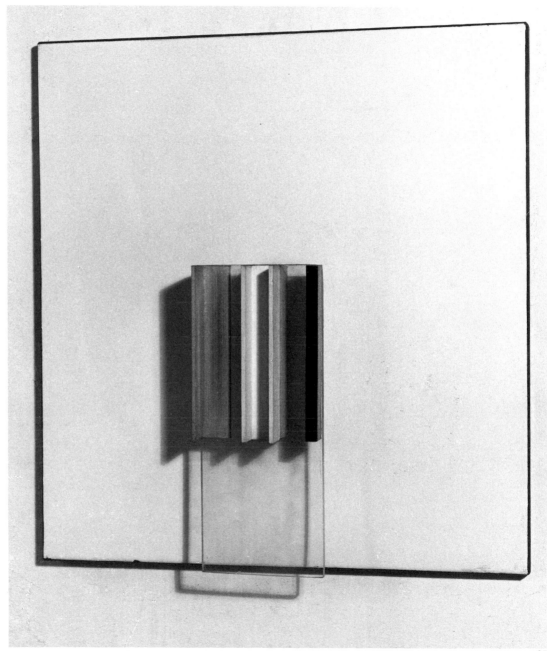

1952-3 and been invited by him to show in the Building Centre exhibition in 1954. Here he had met Hill and for some two years after this they collaborated quite closely. Ernest's first relief dates from 1955 and is influenced by Pasmore. Strips of painted wood and plastic are marshalled in vertical formation in a rhythm determined by the Golden Section. By the time of *This is To-morrow,* where he showed at least one relief, he was using plastic, painted and unpainted plywood and stainless steel. With Hill he visited manufacturers of plastics to obtain samples which they used in the "trans-lated replicas" of pioneer abstract paintings shown at *This is To-morrow* as well as in their own works. Ernest was a meticulous craftsman and used mechanical tools with great skill. His insistence on precise finish influenced Hill,[16] but their use of materials differs. Ernest is fond of treating everyday materials so that their inherent qualities are fully revealed, aluminium sheet is buffed until it glows softly, plywood is varnished to reveal its grain. These surfaces are played off against each other with rather slight variations in depth. He does not use the decisively projecting metal angles and channels so dear to Hill. But they had much in common. Ernest's reliefs of this date are orthogonal and asymmetrically balanced. And like Hill, he was a theoretician and was to write on symmetry and mathematics for *Structure.*

Charles Biederman, with whom Hill had continued to correspond, is an important influence at this period. In a letter to Hill of March 28th, 1955, Biederman urged him, after seeing a photograph of the first relief, *Progression of Rectangles:* "to see the necessity of dumping painting overboard soon" and to become "truly involved with light". As has already been shown, Hill did become "truly involved with light" in the following year and Biederman supported his development. But their disagreements, evident from the start of

their correspondence, paradoxically became much clearer and more strongly expressed now. Biederman thought it "absurd to give up the colour of reality (nature), the spectrum, for the mostly dull and uncontrollable colours of industrial materials".[17] Neither could he accept the use of proportional systems such as "dynamic symmetry", the Golden Section and so on. To him these interfered with abstracting from the "process level of nature". And he thought it was quite wrong for artists to become involved with architecture, as the development of the constructed relief had not advanced far enough and many basic problems had yet to be solved. But despite these differences Hill publicly acknowledged Biederman's importance on several occasions at this time.[18]

In the second half of the 'fifties, as in the first, Hill continued to play a leading part in the Constructionist group's exhibitions and publica-tions. With Ernest and Denis Williams (who had been producing reliefs based on mathematical systems as early as 1953) Hill organised one of the 12 sections at *This is To-morrow.* When discussing Constructionist art Hill has often based its pedigree on the twin roots of De Stijl and Russian Constructivism. He does this, for example, in his statement in *Nine Abstract Artists.* And in his section of *This is To-morrow* he attempted "to re-invoke the decade 1913-23 by means of a display of photographs, etc. and by including a Mondrian and a Gabo along with some replicas and 'translations' of some of the epoch making works".[19] The "translations" included plastic and chip-board versions of paintings by Malevich. Hill's and Ernest's own recent works shown included, as well as reliefs, polystyrene louvres assembled by Hill to suggest an architectural construction of the future and planar tower structures by Ernest of plastic sheet and metal rod.

*This is To-morrow* was followed in the New Year of 1957 by *Statements — a review of British abstract art in 1956* which has been mentioned above, and then at the close of 1957 came another important exhibition: *Dimensions: British Abstract Art 1948-57* at the O'Hana Gallery. Here Hill showed three works, a collage and oil of 1950, *Black Polygons,* and a very recent constructed relief. In the remarkably informative catalogue by Lawrence Alloway and Toni del Renzio, Hill is classified as a "rigorous geometric artist" with Ernest, Kenneth and Mary Martin, Pasmore, McHale and Peter Stroud.

Lawrence Alloway, working at the I.C.A., was one of the very few critics sympathetic to Constructionism at this time. He was involved in several of the Group's activities and wrote the introductions to *Nine Abstract Artists* and to the catalogues of *This is To-morrow,* and *Statements,* as well as *Dimensions.* It was natural that he should write the introduction to the catalogue of Hill's first one-man exhibition

which was held at the I.C.A. in February-March 1958. Hill showed 8 recent constructed reliefs and Alloway sensitively described the light-reflecting qualities of the synthetic materials used in them and commented shrewdly on Hill's avoidance of the heroic symbolism with which Gabo had imbued his constructions of similar materials.

As the decade closed the London Constructionists became more active inter-nationally. In 1958 the journal *Structure* was launched by the Dutchman Joost Baljeu and the Canadian Eli Bornstein (from 1959 Baljeu edited it alone), and most constructionists working in Europe and North America published articles in it before it folded in 1964. Hill introduced it to British readers with a review where he pointed out that it marked "the only group effort since 1923 to advocate the end of painting and postulate a new art which emerges as neither painting or sculpture but something *new: the construction*".[20] In fact *Structure* did not present a united front, an International Group of Constructionists did not emerge, but it was very useful in providing a platform for the airing of topics of mutual interest, and disagreement! Issues were devoted to themes such as *Art and Nature* (II, i, 1959), *Art and Motion* (II, ii, 1960), *Art and Symmetry* (III, i, 1960), *Art and Mathematics* (III, ii, 1961), *Art and Architecture* (IV, i, 1961).

It is a mark of Hill's growing international reputation that he was asked by Max Bill to participate in *Konkrete Kunst* in Zurich in the summer of 1960. This was a major inter-national exhibition of "concrete art" which included all the pioneer abstract artists such as Kandinsky, Kupka, Delaunay, Arp, Mondrian, Vantongerloo, Van Doesburg, Malevich and Moholy-Nagy and also a selection of the artists who were members of *Abstraction-Création* in the 'thirties; Hélion, Bill himself, Nicholson, Taeuber-Arp, Herbin. Amongst the artists who

34. *RELIEF CONSTRUCTION,*
1956-60
Aluminium, plastic, wood,
18 x 29 x 3¾"
K T Powell

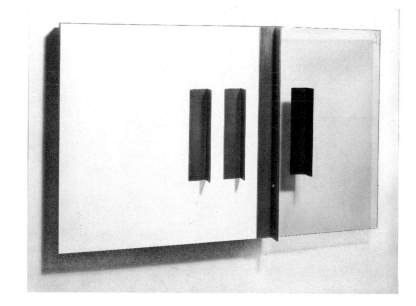

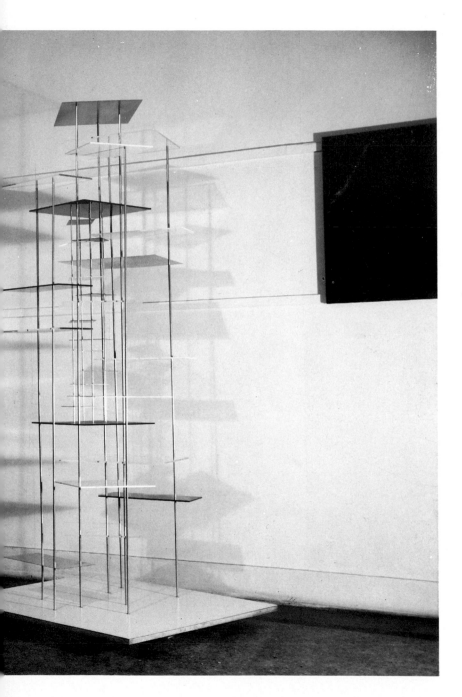

had come to maturity after the Second War, Hill found himself, alongside his English colleagues Kenneth and Mary Martin and Pasmore, in the company of Lohse, Schöffer, Kelly, Agam, Vasarely, Mack and Soto. He showed a mathematically based shallow relief, *Prime Rhythms*, which had occupied him in several different versions since January 1959.

This relief was shown again, together with three others, at what was to prove to be the last group exhibition of the London Constructionists. Titled *Construction: England: 1950-60*, it was held in the New Year of 1961 at the Drian Galleries, Porchester Place. Adams and Heath did not show, their art had developed in other directions following *This is To-morrow*, but Pasmore, Kenneth and Mary Martin, John Ernest and Stephen Gilbert did and they were joined by younger followers such as Gillian Wise and Derek Carruthers. By this date, ten years after the group had initially come together, many of their aims had been achieved and the need to hold together in self-defence was less pressing. Their work was well known both in this country and abroad. It was sold occasionally to discerning private patrons. But Pasmore was exceptional in being able to give up his teaching post in 1961, following the showing of his work at the XXX Venice Biennale in the previous year. Hill, like many of the others, had to rely on a part-time teaching job to earn his living. It was only in 1963 that the Tate Gallery and the Arts Council made purchases of his work.

*THIS IS TO-MORROW,* 1956
Section V, Hill and Ernest

**3. The Orthogonal reliefs;
colour in the materials, real
light and space, 1956-63
Exhibition List**

31. *RELIEF CONSTRUCTION*
October 1956
Plastic, 13½ x 23¾ x 1¼"

32. *RELIEF CONSTRUCTION*
November-December 1956
Plastic, 15½ x 22¾ x 1¼"

33. *RELIEF CONSTRUCTION*
1955-56 and 1983
Plastic, aluminium
24 x 24 x 2½"
The British Council

34. *RELIEF CONSTRUCTION*
1956-60
Aluminium, plastic, wood
18 x 29 x 3¾"
K T Powell

35. *RELIEF CONSTRUCTION*
1956
Plastic, aluminium, brass
36 x 20 x 4⅛"
Southampton Art Gallery

36. *RELIEF CONSTRUCTION* in
two parts, 1956-82
Zinc, brass, 22 x 22 x 3" and
8 x 8 x 1"

37. *RELIEF CONSTRUCTION*
1960-61
Plastic, brass
23½ x 21½ x 1½"

38. *RELIEF CONSTRUCTION*
1956-66
Plastic, brass, 26 x 26 x 2"

39. *RELIEF CONSTRUCTION*
1956-61
Plastic, aluminium
24 x 24 x 3¼"

40. *RELIEF CONSTRUCTION*
1956
Copper, aluminium, plastic
22½ x 15½ x 2¼"

41. i. *RELIEF CONSTRUCTION*
December 1956
Copper, aluminium, plastic
15 x 15 x 1⅝"
The Trustees of the Tate
Gallery
32

ii. *RELIEF CONSTRUCTION*
1956-82
Copper, aluminium, plastic
32 x 32 x 2"

42. *RELIEF CONSTRUCTION*
1956/7-60
Copper, aluminium, plastic
27 x 27 x 4½"

43. *RELIEF CONSTRUCTION*
October 1957
Copper, plastic, aluminium
16 x 17½ x 3½"
Theo Crosby

44. *RELIEF CONSTRUCTION*
1957-76
Copper, aluminium, plastic
16 x 16 x 3"

45. *RELIEF CONSTRUCTION*
June-July 1959
Plastic, aluminium, on
enamelled stove-back
17½ x 16¾ x 4¾"
Private Collection

46. *RELIEF CONSTRUCTION*
June-July 1959
Plastic, aluminium, on
enamelled stove-back
16 x 17 x 2¼"

47. *RELIEF CONSTRUCTION*
August-September 1959
Plastic, aluminium, on
enamelled stove-back
15½ x 23⅞ x 4½"

48. *RELIEF CONSTRUCTION*
June 1963
Plastic, aluminium
18 x 25¼ x 4"

49. *RELIEF CONSTRUCTION*
1962
Plastic, aluminium
26 x 32 x 3¼"
Basildon Arts Trust (Donated
by the Peter Stuyvesant
Foundation)

50. *RELIEF CONSTRUCTION*
1963
Plastic, aluminium
24 x 30 x 3¾"
Victoria and Albert Museum

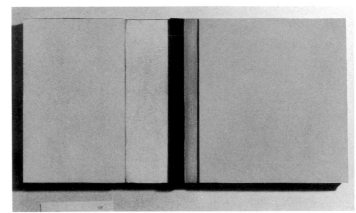

*COMPOSITION*, April 1956
Cream, white and black paint
and perspex on board
11¼ x 22"
(Not exhibited)

*RELIEF CONSTRUCTION*
*c.*1956
White plastic
12 x 13 x 1¾″
(Not exhibited)

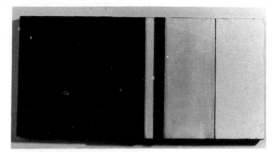

*RELIEF CONSTRUCTION*
March/April 1956
Plastic, black and white paint
on blockboard, 10 x 20″
(Not exhibited)

31. *RELIEF CONSTRUCTION,*
October 1956
Plastic, 13½ x 23¾ x 1¼″

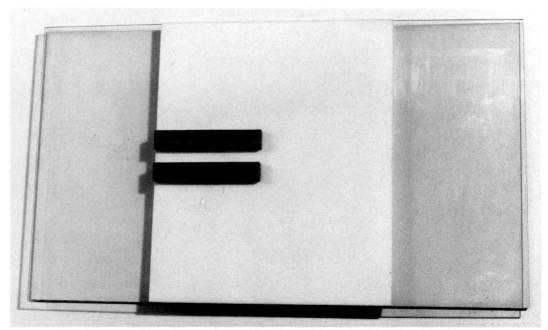

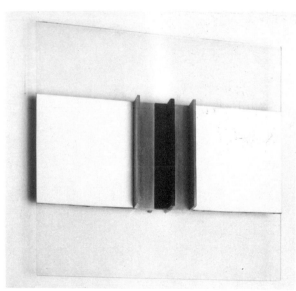

33.
*RELIEF CONSTRUCTION,*
1955-56 and 1983
Plastic, aluminium,
24 x 24 x 2½"
The British Council

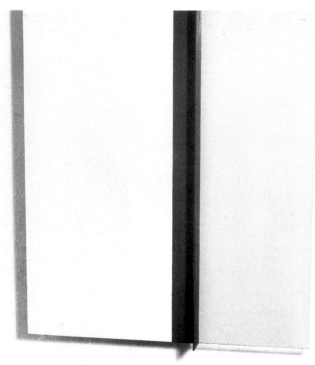

37. *RELIEF CONSTRUCTION,* 1960-61
Plastic, brass, 23½ x 21½ x 1½"

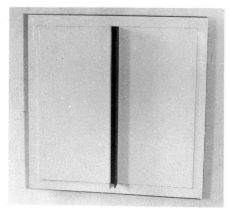

38. *RELIEF CONSTRUCTION,* 1956-66
Plastic, brass, 26 x 26 x 2"

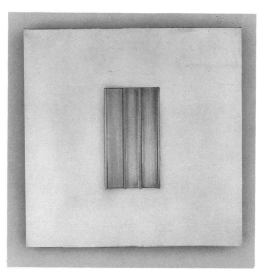

41. i. *RELIEF CONSTRUCTION,* December 1956
Copper, aluminium, plastic, 15 x 15 x 1⅝"
The Trustees of the Tate Gallery

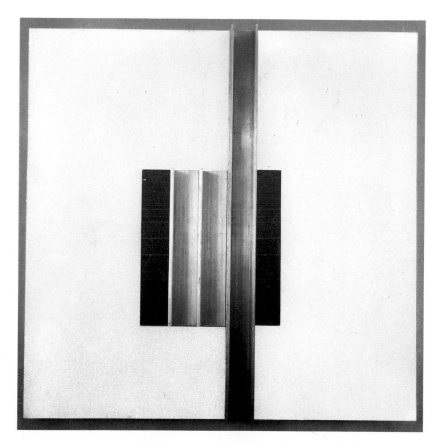

39. *RELIEF CONSTRUCTION,* 1956-61
Plastic, aluminium, 24 x 24 x 3¼"

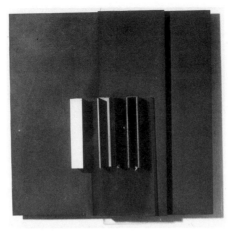

42. *RELIEF CONSTRUCTION,* 1956/7-60
Copper, aluminium, plastic,
27 x 27 x 4½"

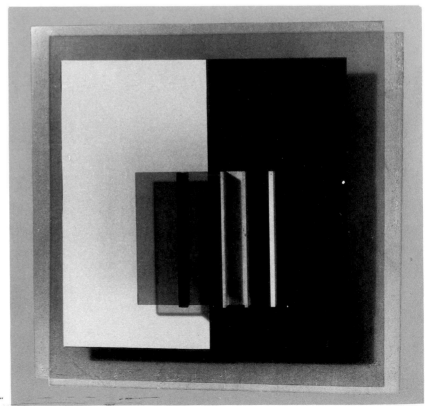

44. *RELIEF CONSTRUCTION,* 1957-76
Copper, aluminium, plastic, 16 x 16 x 3"

45. *RELIEF CONSTRUCTION,*
June-July 1959
Plastic, aluminium, on enamelled
stove-back
17½ x 16¾ x 4¾"
Private Collection

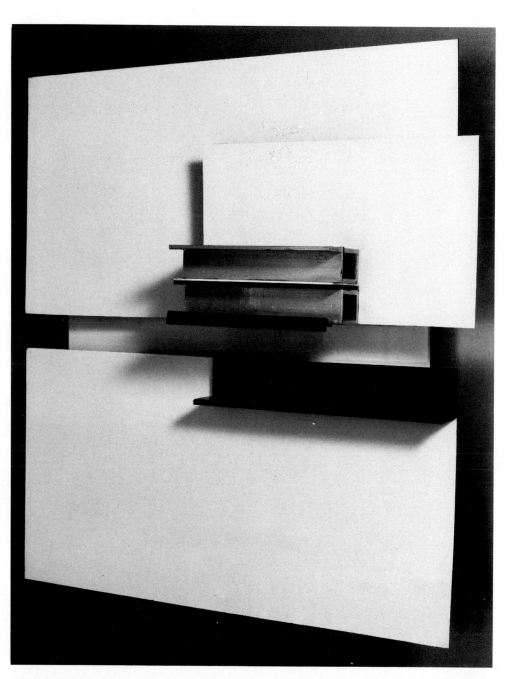

47. *RELIEF CONSTRUCTION*
    August-September 1959
    Plastic, aluminium, on
    enamelled stove-back
    15½ x 23⅞ x 4½"

48. *RELIEF CONSTRUCTION*
    June 1963
    Plastic, aluminium
    18 x 25¼ x 4"

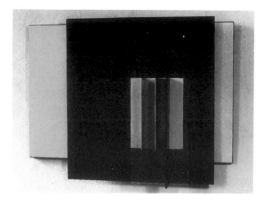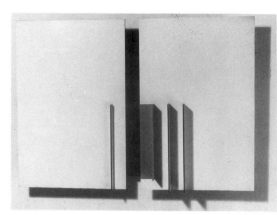

49. *RELIEF CONSTRUCTION*
    1962
    Plastic, aluminium
    26 x 32 x 3¼"
    Basildon Arts Trust (Donated
    by the Peter Stuyvesant
    Foundation)

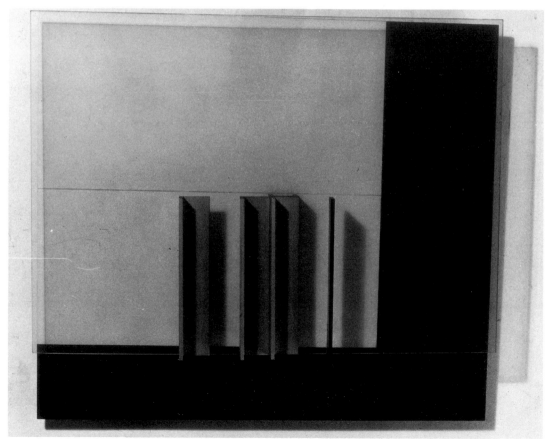

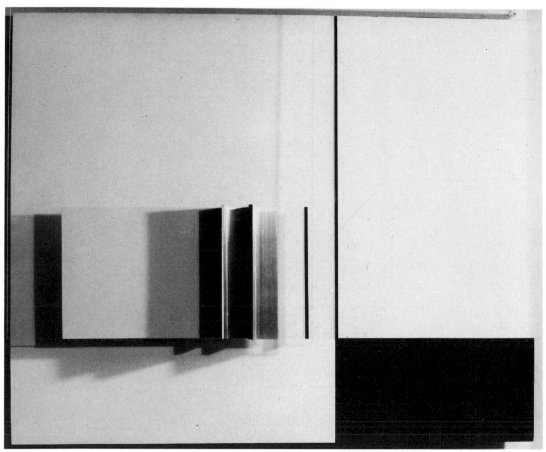

50. *RELIEF CONSTRUCTION*
1963
Plastic, aluminium
24 x 30 x 3¾″
Victoria and Albert Museum

55. *FIVE REGIONS RELIEF,*
1960-62
Aluminium and plastic,
24 x 22 x 1¾"
University of East Anglia
Art Collection, Norwich

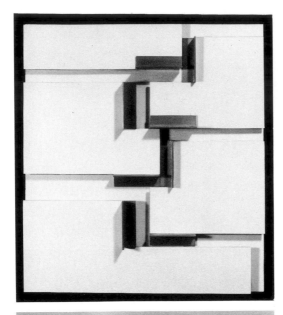

*PRIME RHYTHMS,* 1960
Plastic, 12¼ x 11½"
Adrian Heath
(Not exhibited)

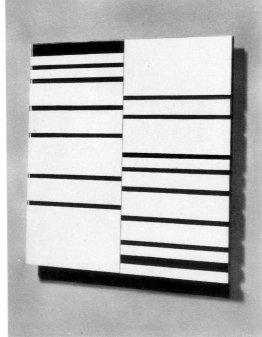

## 4. A Mathematical Art? System and surprise, the reliefs of 1958-69

Though Hill's work evolves logically, step by step, each phase is not distinct but overlaps with the next. Important changes in style occur in 1958-59 and 1961-2 but he continued to make orthogonal reliefs, of the type established in 1956, until 1963 and indeed, some versions of reliefs designed in the second half of the 'fifties were executed a decade or more later. At the end of the 'fifties he becomes more interested in using mathematical ideas as starting points for art works, the space in his reliefs becomes more restricted and less varied, he makes more use of identical units in his compositions and works more than before in series. Examples of these developments can be seen in *Prime Rhythms,* which occupied him in at least five versions between January 1959 and 1962, and the *Reliefs with five regions,* six of which were made between 1960 and 1962. The sequence of positive/negative spaces in *Prime Rhythms* was derived from the distribution of prime numbers between 1 and 100 while the areas of the white planes in the *Reliefs with five regions* were formed by "a partition of a square or rectangle into either equal but not congruent areas or areas using the same congruent bits but expanding". The artist published detailed explanations of both types of relief in 1966.[21]

Another, and more dramatic, change which occurs in the early 'sixties is the introduction of planes set at other than 90° to each other. Although horizontal/vertical orientation continued to be crucial, Hill started to use 90° aluminium angle set at 45° to the base plane in 1961 and in 1962-3 he introduced pieces set at 60° or 120°. He first used angle set at 45° to the base plane in an enormous mural/relief commissioned for the temporary headquarters building of the Sixth Congress of the International Union of Architects held on the

South Bank in July 1961. The theme of the Congress was the influence of new technology and industrial materials on architecture with a sub-theme of the "Synthesis of the Arts".[22] Theo Crosby, the architect of the buildings, persuaded the industrial sponsors, Cape Building Products, Pilkington Glass and the British Aluminium Company, to provide free materials for the artists commissioned for the headquarters building and he selected the artists he considered most suitable for the task of "synthesising" their work with his design. The Constructionists were a natural choice and not only Hill but Ernest and Kenneth and Mary Martin were asked to collaborate. Hill's mural/relief occupied a raised space where the ceiling height changed by 7' and was 48' long with planes 1' 6½" deep, so it was by far the largest work he had designed. He described it in an issue of *Structure* devoted to *Art and Architecture:*

> "What I have made amounts to a screen. The wall area is affirmed by a continuous region of white . . . Parallel to this are large elements of glass and aluminium in the form of squares and vertical rectangles. The vertical dimensions are repeated but

are smaller than those of the wall space. These elements are back fixed and at various levels, space flows around them and behind them — they will be seen as 'floating' planes.

The second set of levels comprises aluminium extrusions, angle sections, etc., which are fixed directly to the panels of glass and aluminium. The dimensions and position of the vertical elements arise out of the attempt to articulate the panels in three directions. The whole structure exploits transparency, shadow and reflection and is technically a construction utilising space and planes and no mass.

The screen is itself a sort of architecture — as well as being a simple form of light modulator."[23]

Normally Hill's work is on a domestic scale. His reliefs are self-contained, easily perceived constructions of "pure architecture". When called upon to produce a large scale work for the Congress building he did not simply design a magnified version of a constructed relief. He had to recognise "conditions arising out of the physical requirements and the psychological

*I.U.A. MURAL RELIEF,*
South Bank, 1961
7' x 48' x 1' 6½"

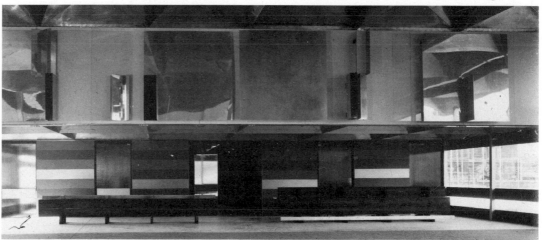

function which normally are not those to be found in a purely plastic construction".[24] So the large scale work in an architectural setting became "impure architecture" as it answered functional requirements. The mural/relief at the I.U.A. Congress served to dissolve the abrupt transition of levels between two ceiling areas. It reflected the intricate roof structure and took up and echoed the materials of which the building itself was constructed.

Two of the vertical elements in the mural/relief are of right-angle section positioned at 45° to the base plane, producing more varied light reflections than in earlier, entirely orthogonal constructions. Hill used these right-angle sections positioned at 45° in some reliefs of 1962 and either in the same year, or early in the next, discovered extruded aluminium section of 120°. Just as his discovery in 1956 of right-angle section aluminium helped to spark off his orthogonal, constructed reliefs so the finding now of the 120° section started a

new sequence of works which continued until 1970 and went through many variations. He used it in units of two squares measuring 1" x 1" x ⅛" joined at 120° with one face always parallel to the base plane. As the units are identical, the only way of telling one from another is by their position. Light reflected from their sloping surfaces reveals similarities and differences in their orientation. To facilitate recognition of the systematic permutations, space is more limited than in the earlier reliefs and the units are kept at equal height. They are mounted on rectangular base planes of sheet materials which set them off by contrasts of colour and of light-reflecting qualities. For the base planes Hill used not only the familiar black, white and transparent plastic but also ivory white, grey smoked and amethyst tinted plastic, or sheet steel or aluminium. Sometimes he blackened the ends of the units to give further distinct variation.

The possible permutations of the units seems endless but Hill was anxious to make easily grasped, satisfying compositions and limited himself to a few thoroughly explored combinations. In some reliefs of 1963-4 the units are placed in four or more horizontal rows with the same number in each row, "pointing" in the same direction in each row, but with different positions on the rectangular grid of the base planes (nos. 60, 61). He does this in a simpler form in the series of *Quadrant* reliefs in which pairs of units are placed with rotational symmetry on quartered base planes of counter-changed materials (nos. 62, 63, 64, etc.). In these and other related reliefs (no. 65) the new rotational movement suggested is similar to that found in Joost Baljeu's reliefs after 1956 and in some of Mary Martin's *Permutation* reliefs made of units of steel faced half-cubes which were started in *c.*1963.

In many reliefs of this period, beginning in 1963, Hill combines the 120° units into

63. *RELIEF CONSTRUCTION J2*, 1966
24 x 24 x 3"
Private Collection

65. *RELIEF CONSTRUCTION G2*, 1966
Plastic, steel, aluminium,
21⅛ x 21⅛ x 3"
The Arts Council of Great Britain

61. *RELIEF CONSTRUCTION E1*, 1963-4
Plastic and aluminium,
30 x 30 x 2¼"
Knoedler Gallery, London

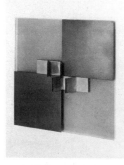

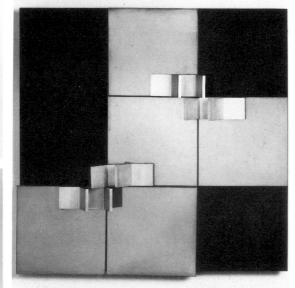

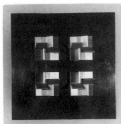

grouped columns (e.g. nos. 72, 73). He is particularly fond of a combination called the *Divine Tetraktus:* 1+2+3+4=10, i.e. 10 units will be combined in 4 columns with 1, then 2, then 3, then 4 units per column. He opposes and counterbalances each stepped block with an identical block placed against it in a symmetrical relationship. Examples of this can be seen in the lozenge shaped reliefs started in 1965 where the two blocks of units are placed on the diagonal and also in the *Screens,* which date from the same time, where the blocks are vertical.

The *Screens* are a "by-product" from another large scale architectural project which, in this case, was not realised. Since the I.U.A. Congress, Hill had met the French urbanist Yona Friedman and this meeting, Hill has said:

"had the effect of entirely disengaging me from the question of synthesis of art and architecture. Apart from the immediate

appeal of his visionary urbanistic thought I later found that our common interest lay in pure structure."[25]

The projected *Screen* was to have been a "pure structure" built to replace a wall at the entrance to the Engineering laboratory at Cambridge University. Kenneth Martin and Robert Adams also took part in the limited competition for the site and Martin's entry was selected. Hill submitted a maquette for a double-sided, free standing, aluminium screen with two pairs of stepped blocks of 120° units on each side separated by flat planes. The maquette was in four sections which the selection committee could combine as they pleased and so gain insight into the differences and similarities between the various parts. Hill intended the finished screen to be non-transformable and completely of aluminium. He continued to make versions of it, some with plastic planes between the blocks of angled elements, until 1969 when he showed three of them at his

*RELIEF CONSTRUCTION,*
1965
Aluminium and perspex
30 x 30 x 3½"
Rijksmuseum Kröller-Müller,
Otterlo
(Not exhibited)

*MAQUETTES FOR
CAMBRIDGE SCREEN*
(Not exhibited)

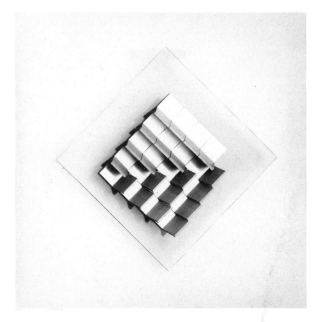

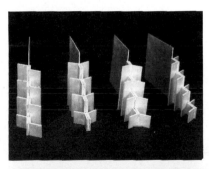

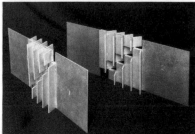

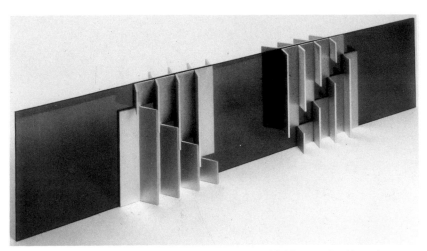

MAQUETTE FOR SCREEN
(Not exhibited)

second one-man exhibition at the Kasmin Gallery.[26]

Differences and similarities, sometimes surprising as they both occur when least expected, are also very evident in the *Partition reliefs* of 1966-9. Here 24 units are placed on the diagonal in pairs in parallel rows. The pairs are permuted so that they mirror and contrast with their partners and with adjacent pairs. By very simple means Hill has created effects of intriguing complexity, indeed of satisfying mystery.

Works such as these raise the question — "To what extent is Hill a mathematical artist?" As we have seen the works of this period, starting with *Prime Rhythms,* show an increased use of systematic procedures. His research into pure mathematics, into combinatorics and topology, also took up more of his time now. He published his first mathematical paper, with F. Harary, in 1963 — *On the number of crossings in a complete graph* — and others followed in 1966 and 1969. But his mathematical ideas did not dominate his art. Judgment by eye was always of paramount importance to him and mathematical systems

were only starting points or tools used in the creation of an harmonious object. In 1961 he wrote, in the issue of *Structure* devoted to *Art and Mathematics:*

"An artist drawn towards mathematics will not achieve much by using mathematics to make a painting any more than the converse of trying to be mathematical with paint. . . .On no account does the constructionist wish to station himself so as to be illuminated by the glamorous light that radiates from the citadel of mathematics."[27]

He was critical of Gabo for coming close at times to emulating mathematical models and of some of the Swiss Concrete artists for being too patently didactic, too close to Froebel, in their systematic paintings.[28]

The decade of the 'sixties was extremely fruitful, for not only did he combine research into mathematical problems with his art production but he also took part in several major exhibitions, held three one-man exhibitions and contributed articles to important publications. His showing in Bill's *Konkrete Kunst* exhibition in Zurich in 1960 was the start of much more frequent representation in international exhibitions than had been the case in the previous decade. (See the *List of Exhibitions,* p. 71-73).

Not only did all these exhibitions mean that Hill's work now had a wide audience here and abroad but they also led to important sales. The Tate Gallery, the Arts Council and the Gulbenkian Foundation made their first purchases in 1963. The Stuyvesant Foundation bought works in 1965 and 1966. The two one-man exhibitions at Kasmin's Gallery brought further purchases from the Arts Council, the Tate, from the Kröller-Müller Museum and from several American private collectors such as Lipschultz in Chicago who bought the largest version of *Prime Rhythms.*

78. *RELIEF CONSTRUCTION
(PARTITION H2),* 1969
Aluminium and plastic,
40 x 40 x 1¾"
Knoedler Gallery, London

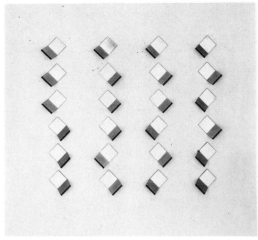

Given the extent of his exhibitions in the decade
it is surprising that he was also able to write
several theoretical essays. He continued to
contribute articles to *Structure* until it ceased
publication in 1964. In 1966 he published a
history of Constructivism in *Studio International*
and an analysis of four of his own reliefs in
Gyorgy Kepes' anthology *Module, Proportion,
Symmetry, Rhythm.* In 1968 an investigation
into Mondrian's compositions appeared in
*Leonardo* and in the same year he edited an

ICA 1963
Exhibition with Gillian Wise

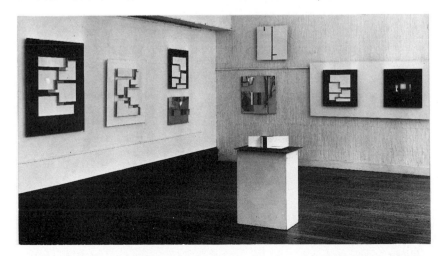

anthology titled *Directions in Art, Theory and
Aesthetics.*

*DATA,* published by Faber, is an important
collection which was conceived as a successor
to *Circle,* the international survey of
Constructive art, published by the same firm in
1937. Hill called for essays from twenty-three
artists with the aim of "exploring *polemical*
issues in the field of abstract art." He also
invited contributions from a philosopher, a
mathematician, a physicist, an engineer, a
sociologist and an experimental urbanist. In his
introduction Hill remarked that the most
characteristic theme of the essays in the
anthology was the relationship of art to science
and he concluded:

> "My own belief is that ultimately all aspects
> of modern art will be open to scientific
> enquiry, and it is interesting to speculate
> how this might be achieved, as well as the
> effects it might produce in terms of a feed-
> back to the artists and the public."[29]

Hill's own essay explained the importance of
paragrams, charts, graphs, in the investigation
of structure. The ideas discussed are directly
related to his contemporary art works. For
example he quotes from the mathematician
and bio-physicist Rashevsky writing about the
topology of molecular structures:

> "It is, however, possible for an aggregate
> of identical physically indistinguishable
> units to have a large information content.
> The units in this case, though indistinguish-
> able physically, are different through *the
> difference of their relations to each
> other.*"[30]

He also quotes a definition of topology by the
physicist David Bohm: "In essence the study of
the order involved in the placing of one thing in
relationship to another."[31] This definition might
well serve as a motto for Hill's art in this
decade and the next.

## 4. A mathematical art? System and surprise, the reliefs of 1958-69 Exhibition List

### 4A. Prime Rhythms. The Relief with five regions

51. *CONSTRUCTION – THREE VERTICAL ELEMENTS,* 1957
Black pvc, white Formica, chipboard, 15¼ x 9¼ x 1¹/₁₆″
Dr Michael Morris

52. *PRIME RHYTHMS,* 1958-62
Plastic, 19¾ x 19⅝ x 1¾″
Dr Michael Morris

53. *FIVE REGIONS RELIEF*
1960
Aluminium and plastic
36 x 36 x 4″
Whitworth Art Gallery,
University of Manchester

54. *FIVE REGIONS RELIEF*
1960-62
Aluminium and plastic
43½ x 36 x 1⅞″
The Trustees of the Tate Gallery

55. *FIVE REGIONS RELIEF*
1960-62
Aluminium and plastic
24 x 22 x 1¾″
University of East Anglia Art
Collection, Norwich

56. *FIVE REGIONS RELIEF,* 1961
Aluminium and plastic
24 x 24 x 1¾″
Adrian Gale

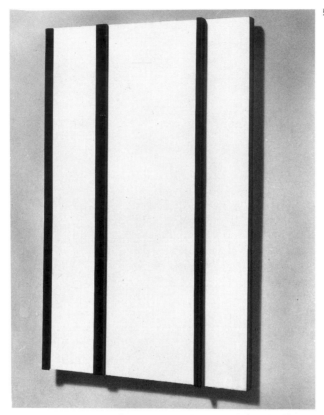

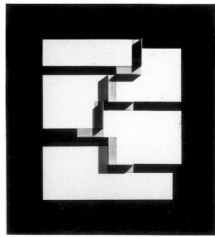

51. *CONSTRUCTION – THREE VERTICAL ELEMENTS,* 1957
Black pvc, white Formica, chipboard, 15¼ x 9¼ x 1¹/₁₆″
Dr Michael Morris

54. *FIVE REGIONS RELIEF*
1960-62
Aluminium and plastic
43½ x 36 x 1⅞″
The Trustees of the Tate Gallery

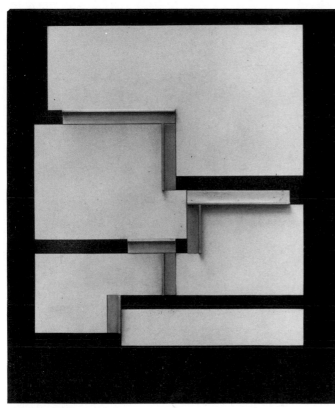

*FIVE REGIONS RELIEF*, 1961
Aluminium and plastic
24 x 22 x 1¾"
Huddersfield Art Gallery
(Not exhibited)

*FIVE REGIONS RELIEF*
1960-61
Vinyl and aluminium
30 x 24 x 3½"
Calouste Gulbenkian
Foundation
(Not exhibited)

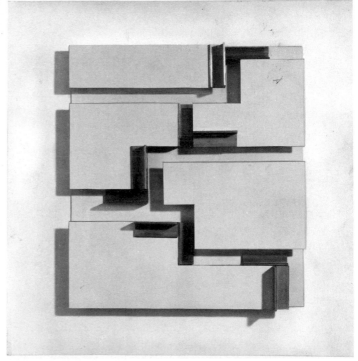

## 4B. I.U.A. Mural-relief, Quadrant reliefs. Freedom from the right angle, freeing of light

57. *MAQUETTE FOR SOUTH BANK I.U.A. RELIEF/ MURAL*, 1961
Aluminium, plastic
7 x 48 x 1½"

58. *DRAWING FOR SOUTH BANK MURAL*, 1961
Pencil, ink, crayon
15¼ x 52¼"

59. *RELIEF CONSTRUCTION (PARTITIONS)*, 1963-4
Plastic and aluminium
18 x 26 x 2"
Private Collection

60. *RELIEF CONSTRUCTION C6, (PARTITIONS)*, 1962-3
Plastic and aluminium
36 x 36 x 2¼"

61. *RELIEF CONSTRUCTION E1*
1963-4
Plastic and aluminium
30 x 30 x 2¼"
Knoedler Gallery, London

62. *RELIEF CONSTRUCTION J1*
1968-9
Aluminium, steel, plastic
24 x 24 x 3"

63. *RELIEF CONSTRUCTION J2*
1966
24 x 24 x 3"
Private Collection

64. *RELIEF CONSTRUCTION G1*
1966
Plastic, aluminium, steel
30 x 30 x 3"

65. *RELIEF CONSTRUCTION G2*
1966
Plastic, steel, aluminium
21⅛ x 21⅛ x 3"
The Arts Council of
Great Britain

66. *RELIEF CONSTRUCTION G6*
1970
Plastic, aluminium, (2 painted black all over)
11⅞ x 19⅜ x 3¼"

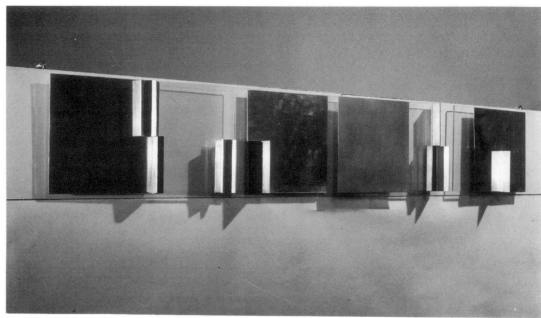

57. *MAQUETTE FOR SOUTH BANK I.U.A. RELIEF/ MURAL*, 1961
Aluminium, plastic
7 x 48 x 1½"

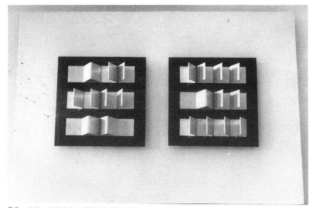

59. *RELIEF CONSTRUCTION (PARTITIONS)*, 1963-4
Plastic and aluminium
18 x 26 x 2"
Private Collection

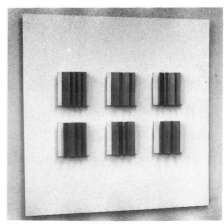

60. *RELIEF CONSTRUCTION C6, (PARTITIONS)*, 1962-3
Plastic and aluminium
36 x 36 x 2¼"

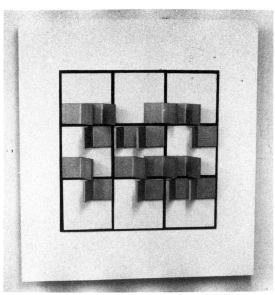

*RELIEF CONSTRUCTION C1*
1963
Aluminium, ivory and
black pvc, 26 x 24 x 3"
(Not exhibited)

*RELIEF CONSTRUCTION C2*
1962-64
Aluminium and black vinyl
sheet, 26 x 24 x 3"
(Not exhibited)

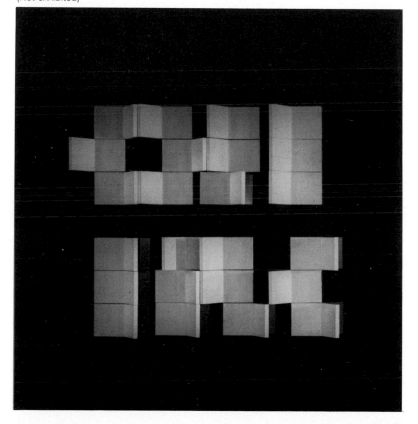

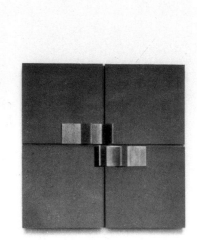

64. *RELIEF CONSTRUCTION G1*
1966
Plastic, aluminium, steel
30 x 30 x 3″

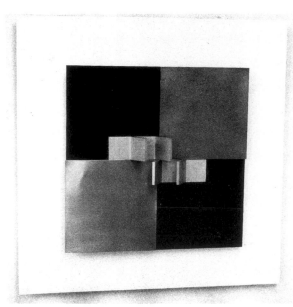

62. *RELIEF CONSTRUCTION J1*
1968-9
Aluminium, steel, plastic
24 x 24 x 3″

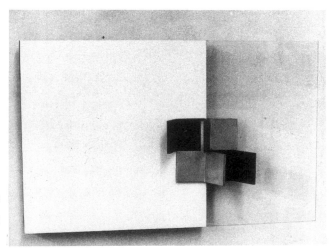

66. *RELIEF CONSTRUCTION G6*
1970
Plastic, aluminium, (2 painted
black all over),
11⅞ x 19⅜ x 3¼″

**4C.**

67. *LOW RELIEF,* August 1963
    Plastic, 24 x 48 x ¼″
    Peter Stuyvesant Foundation

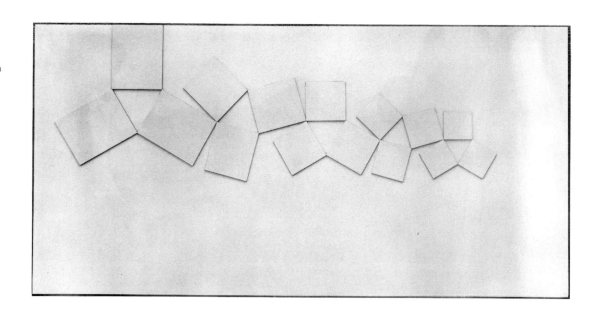

## 4D. The Screens. Reliefs using the 'Divine Tetraktus'

68. *SCREEN I, c.*1965-9
Aluminium, 10 x 50½ x 4"

69. *SCREEN No 2,* 1968-9
Aluminium and plastic
12½ x 62¼ x 4"
The Trustees of the Tate Gallery

70. *SCREEN No 3, c.*1965-9
Aluminium, 12 x 160 x 4"

71. *SCREEN No 4, c.*1965-9
Aluminium and plastic
12 x 92⅛ x 4"
The Arts Council of
Great Britain

72. *RELIEF CONSTRUCTION C3*
1963
Plastic and aluminium
24 x 24 x 4"

73. *RELIEF CONSTRUCTION*
1963-4-9
Plastic and aluminium (partly
painted), 24 x 24 x 3¼"
The Trustees of the Tate Gallery

74. *RELIEF CONSTRUCTION F3*
1965-6
Plastic and aluminium
42 x 42 x 3½"
The Arts Council of
Great Britain

75. *RELIEF CONSTRUCTION F4*
1966
Plastic, aluminium, steel
36 x 36 x 3½"
Scottish National Gallery of
Modern Art, Edinburgh

76. *RELIEF CONSTRUCTION*
1965
Plastic and aluminium on
board, 30 x 41½ x 3"
Knoedler Gallery, London

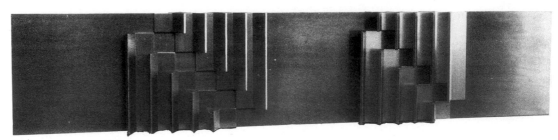

70. *SCREEN No 3, c.*1965-9
Aluminium, 12 x 160 x 4"

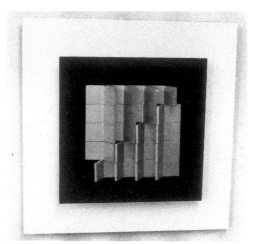

72. *RELIEF CONSTRUCTION C3*
1963
Plastic and aluminium
24 x 24 x 4"

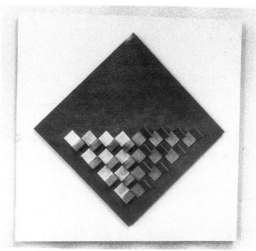

*RELIEF CONSTRUCTION F1*
1965
Plastic, aluminium
19 x 19 x 3½"
(Not exhibited)

76. *RELIEF CONSTRUCTION*
1965
Plastic and aluminium on
board, 30 x 41½ x 3″
Knoedler Gallery, London

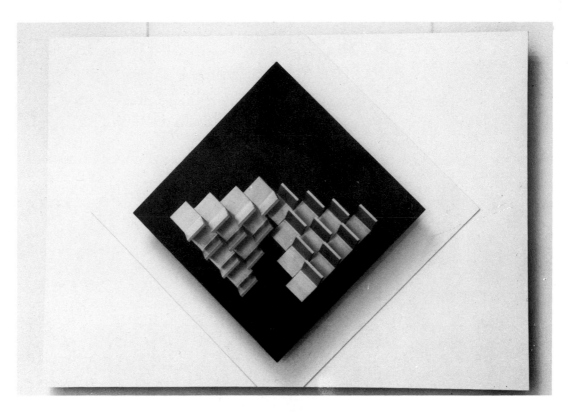

**4E. Partition Reliefs**

77. *RELIEF CONSTRUCTION
(PARTITION H1),* 1966-7
Aluminium with black edges,
plastic, 30 x 30 x 1¾″

78. *RELIEF CONSTRUCTION
(PARTITION H2),* 1969
Aluminium and plastic
40 x 40 x 1¾″
Knoedler Gallery, London

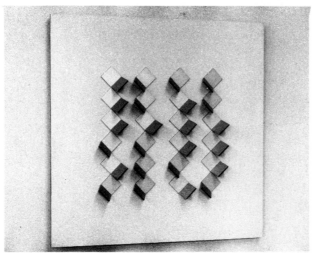

77. *RELIEF CONSTRUCTION
(PARTITION H1),* 1966-7
Aluminium with black edges.
plastic, 30 x 30 x 1¾″

## 5. The Influence of graph-theory; Parity Studies, Co-structures, low reliefs of white laminated plastic with permuted units, 1969 to the present

Hill's interest in topology had begun right at the start of his artistic career when, in 1950, he discovered Max Bill's sculpture, *Endless ribbon,* inspired by the Möbius strip and read an article by Buckminster Fuller on his theory of design.[32] In fact his interest must have been present even earlier as it can be seen in the *String construction,* made before 1950, which prefigures so much of what was to come in later work. His research into combinatorial mathematics and graph theory reached a professional level when, in 1971-2, he worked as an Honorary Research Fellow in the Mathematics Department of University College, London, with a grant from the Leverhulme Foundation. The results of his research, always done in collaboration with others, were published in mathematical journals during the first half of the 'seventies.

Hill's art of the last decade and a half has reflected his mathematical interests. The series of reliefs called *Parity Studies* are an example. One of these (no. 80) was shown as early as 1969 in his second Kasmin Gallery exhibition where it hung with a group of *Partitions* and *Quadrant reliefs* and the *Screens.* Several others were made in the first half of the 'seventies and three were exhibited at the Hayward Gallery in the winter of 1975. All use the motif of the familiar 120° angle but now laid flat rather than projecting into space. In the *Parity Studies* the 120° units are combined into eight groups of three. They do not form closed hexagons but are linked as "trees" in horizontal and vertical compositions. Each asymmetric group of three 120° units is kept separate. The materials used for this series vary. The version shown at the 1969 Kasmin Gallery exhibition was made from white-faced engraver's laminated plastic with the design cut in matt black. The engraving was done by professionals with extreme precision. Hill makes much use of this technique over the next decade and indeed, up to the present. Here it is used to produce a very forceful image with the same carrying power as some London Underground signs or of Kenneth Martin's contemporary paintings such as *Black Sixes* (1967-8). Other versions of the *Parity Studies* were made from paint on plastic, white on black or coloured so as to distinguish the units, and from aluminium strip on sheet plastic or stainless steel. They have square formats and are hung as lozenges.

*PARITY STUDY THEME 1,*
1969
Engraved plastic, 40 x 40"

81. *PARITY STUDY THEME 2, FIRST VERSION,* 1970-74
Paint on perspex,
68⅞ x 67"
The Arts Council of
Great Britain

The *Hexor* and *Linear Construction* series, completed in 1976 and 1977 respectively though designed several years earlier, are related to the *Parity Studies*. Here the six branched "trees" control clusters of six or seven hexagons. Only the outside lines of the hexagons are inscribed and this creates some visual ambiguity for they can be read as cubes even though seven of the sides are missing. This ambiguity is particularly noticeable in the *Linear Constructions*. Hill was aware of it and nick-named these works "perceptual flip-flops". They are akin to the engraved drawings of Albers made of the same materials but with more extreme play with optical effects.

Hill's adoption of engraver's plastic meant that he had abandoned the often dramatic contrasts of light and shade found in his earlier reliefs. But light and shade, and the movement of the spectator, are still very important in these "flat" reliefs. From some points of view the engraved line or the black edge of a raised plane disappear and the spectator is presented with a "white-out". But when the spectator moves, lines and edges reveal themselves in what appear to be slightly changing thicknesses while others, in turn, disappear. Hill had first noticed this effect when making *Low Relief* in 1963 (no. 67) in which rectangles of white sheet plastic are mounted on a base plane of the same material, but he was only to exploit it fully in reliefs made after 1974 such as the *Homage to Khlebnikov* series.

79. *CO-STRUCTURE, VERSION 3,*
*HOMMAGE À*
*ROBERTO FRUCHT,* 1970-5
Welded stainless steel on
24" module

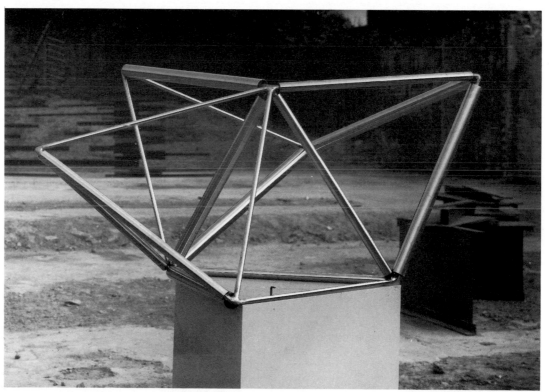

As though to counter-balance his move to "flat" reliefs Hill started, in 1970, to develop his *Co-structures* — free-standing constructions, made from lengths of tube, using a variety of geometric configurations. An explanation of the stainless-steel version, titled *Homage to Roberto Frucht*, is provided by the artist:

> "it is a representation of an abstract 3-polytope made with all edges of equal length. The 3-polytope is the smallest asymmetric polyhedron all of whose faces are 'triangles'. The eighteen edges comprise a partition into three sets of identical trees, the smallest asymmetric tree. The trees have been distinguished by giving each set edges of differing thicknesses. The work is dedicated to the mathematician Roberto Frucht, who was a pioneer in the field of groups of graphs and with whom I was then corresponding."

Other *Co-structures* were made from plastic piping held together by nylon thread which allowed them to be articulated. One of these was the subject of a videotape made by Yona Friedman in 1972. A plastic version in black and white and grey was shown with the stainless-steel version at the Hayward Gallery in November 1975.

In the summer of 1977 Hill exhibited again at the Hayward in the first of the *Annuals*. It was an important showing of recent work which included all three of the relief series titled *The Nine — Homage to Khlebnikov*,[33] and four of the *Rebis* series. All the works were of white faced engraver's laminated plastic and the relief element in them was minimal — merely the depth of plastic sheet from which the units of the compositions were cut. But, though minimal, the relief element is important for the cut edges reveal the matt black core of the white faced plastic and throw thin, yet distinct, shadows onto it. Whereas in the previous decade Hill had made strong distinction between the units of his compositions and the base planes on which he mounted them, he now unifies them. They are of the same material. So these reliefs are more homogeneous than any before and there is nothing to distract attention from the configurations of black lines.

As before, compositions are constructed with identical units which are permuted singly or in groups of two or three. The units are the same shape as those made of aluminium in earlier reliefs though they are unfamiliar as they are now made of white faced plastic and are placed flat. In the series *The Nine — Homage to Khlebnikov* the unit is "L" shaped. It is used in groups of three to show: "the nine distinct ways of embedding the smallest asymmetric tree on the orthogonal lattice such that a set of very strict parameters define the smallest family."[34] In the *Rebis* series, the 120° unit is used. As in the *Partition* reliefs, twelve units are paired in columns. The positions of the units are varied so that each one differs from its partner and yet shares some characteristic.

The "L" shaped unit of construction, which first appeared in the orthogonal reliefs of 1956, continues to be used in works of the late 'seventies. In *Linear Formact* of 1978-9 it is inscribed in matt black three times, an inevitably asymmetric grouping. The units are placed so that their open "arms" point to three different parts of the squares into which they are cut — side, corner and centre. In *Changing Formact A*, of the same date, two groups of three white "L" shaped units are aligned on each side of an open, central channel. Though asymmetric in its parts the overall composition of this relief conveys a powerful sense of symmetry resembling that found in Robyn Denny's series of paintings titled *Travelling* which were shown in the 1977 *Hayward Annual*. The resemblance is not surprising as the two artists are con-

*THE NINE – HOMMAGE À KHLEBNIKOV*, No. 3, 1976
36 x 36"
Private Collection, Chicago
(Not exhibited)

93. *LINEAR REBIS*, 1976-7
Laminated plastic,
31⅞ x 29⅞"

temporaries and friends and share admiration for Albers and Biederman.

In other reliefs of this time Hill finds different methods of distinguishing the units he uses and the directions in which they face. For example in *Ingine I*[(35)] he bisects the corner of a square with a line struck to the diagonal; again he permutes the units in groups of three. In *Ingine 2* he simply cuts off one corner of a square which is again permuted in groups of three. In more recent works, the *Turmach* series,[(36)] the earliest of which were shown at his last one-man exhibition at the Knoedler Gallery in November 1980, he has returned to the 120° unit linked into hexagons which are grouped in threes. In these works Hill attempts: "to root the theme in a context of generative algorithmic procedures and so challenge the viewer with the idea that the work was produced not by a human but by a Turing Machine." The conceptual quality of some of these recent works is contrived deliberately.

Despite the clear changes in Hill's work over the past three decades a remarkable consistency emerges. He is able to develop steadily from the discoveries he has built into his art since the early 'fifties. It is this ability which makes his present rather isolated position less painful than it might otherwise be. He is preoccupied today, as he always has been, with the problem of how to make works which are at once harmonious and surprising, related to our own day-to-day lives yet rooted in specific events in the historic development of abstract art.

98. *CHANGING FORMACT A*, 1978-9
    Laminated plastic, 33 x 33″
    Atlantic Richfield Collection

**FOOTNOTES**

1.  *Constructionism.* The term derives from
    C. Biederman, *Art as the Evolution of Visual
    Knowledge,* Red Wing, 1948, pp. 390-400.
    It is used by the English artists from 1952. See,
    for example, K. Martin: *An Art of Environment,
    Broadsheet No. 2,* (June 1952) and A. Hill, *The
    Constructionist Idea and Architecture, Ark,*
    No. 18, (Nov. 1956), pp. 22-29. They had
    stopped using the term by *c.*1964.

2.  For example T. del Renzio, *First Principles, Last
    Hopes, Typographics,* 4, 1951, pp. 14-20.

    R.V. Gindertael, *Peintres Britanniques
    d'Aujourd'hui, Art d'Aujourd'hui,* 4, ii, March
    1953, pp. 12-15.

    L. Alloway, *Arte non-figurative inglese, Arti
    Visive,* 6-7, Rome, January 1954.

3.  *The Spectacle of Duchamp, Studio
    International,* 189, no. 973, January-February
    1975, pp. 20-22.

4.  A. Hill, *Max Bill, the search for the unity of the
    plastic arts in contemporary life, Typographica,*
    7, (1953), p. 21.

5.  Hill read R.P. Lohse, *A revised thematics for
    progressive art, Transition,* 1952, I, iii, pp.
    163-164.

6.  L. Alloway, *Nine Abstract Artists,* London,
    1954, p. 28.

7.  L. Alloway, *Nine Abstract Artists,* pp. 15, 16.

8.  See A. Grieve, *Charles Biederman and the
    English Constructionists, Burlington Magazine,*
    No. 954, CXXIV, Sept. 1982, pp. 540-551
    and forthcoming.

9.  L. Alloway, *Arti Visive,* January 1954, n.p.n.

10. L. Alloway, *Nine Abstract Artists,* p. 15.

11. Tate Gallery, *Illustrated catalogue of
    acquisitions 1974-6,* London, 1978, pp. 109,
    110.

12. A. Hill, *This is To-morrow,* Whitechapel Art
    Gallery, London 1956, introduction to Section V.

13. *Statements — a review of British abstract art in 1956*, I.C.A., London, 16 January — 16 February, 1957, no. 12.

14. *Structure*, II, ii, 1960, p. 59.

15. Two such works are illustrated in *Nine Abstract Artists*, plates 44 and 47.

16. A. Hill, *A view of non-figurative art and mathematics . . .*, Leonardo, X, 1977, p. 8.

17. Letter to Hill of June 11th, 1955.

18. See e.g. A. Hill, *The Constructionist Idea and Architecture*, Ark, 18, Nov. 1956, pp. 24-9.

   A. Hill, *Charles Biederman and Constructionist Art*, Broadsheet No. 3, Dec. 1957.

   A. Hill, *Introducing "Structure"*, Art News and Review, XI, xii, July 4th 1959, p. 2.

19. *This is To-morrow*, Whitechapel Art Gallery, London 1956, Introduction to Section V. In fact the Mondrian and Gabo loans did not materialise.

20. *Introducing "Structure"*, Art News and Reivew, pp. 2, 10.

21. G. Kepes (ed), *Module, Proportion, Symmetry, Rhythm*, New York, 1966. Chapter by Hill: *The Structural Syndrome in Constructive Art*. And see Hill's review of M. Holt, *Mathematics in Art*, in Leonardo, IV, iv, 1971, pp. 395, 396. Hill stopped research into the distribution of primes after reading of Stanislavlilam's discoveries in *Scientific American*, 1964.

22. For a full report of the Congress buildings and art see *Architectural Design*, XXXI, xi, 1961, pp. 482-509.

23. *Structure*, IV, I, 1961, p. 19.

24. *Structure*, IV, I, 1961, p. 22.

25. K. Frampton, *Anthony Hill interviewed, Studio International*, 172, no. 882, 1966, p. 201.

26. For a statement on the *Screens* see *The Tate Gallery 1968-70 Report*, 1976, p. 88.

27. *Structure*, III, ii, 1961, p. 63.

28. See above and *Kalte-kunst - a manifesto?, Art News and Review*, XI, v, March 28th 1959, pp. 5, 14.

29. *DATA*, pp. 10-11.

30. *DATA*, p. 259.

31. *DATA*, p. 259.

32. Buckminster Fuller, *Comprehensive Design, Transformation*, I, i, 1950, pp. 18-23.

33. Khlebnikov was a Russian Formalist poet who influenced Tatlin.

34. Explanation by the artist and see Hill, *A view of non-figurative art . . .*, Leonardo, X, 1977, pp. 9-12.

35. *Ingine* is derived from the mathematical term "Turing Machine".

36. *Turmach* is derived from the mathematical term "Turing Machine".

**5. The influence of graph-
theory. Parity Studies,
Co-structures, low reliefs
of white laminated plastic
with permuted units, 1969
to the present
Exhibition List**

**5A.**

79. *CO-STRUCTURE, VERSION
3, HOMMAGE A ROBERTO
FRUCHT,* 1970-5
Welded stainless steel on
24″ module

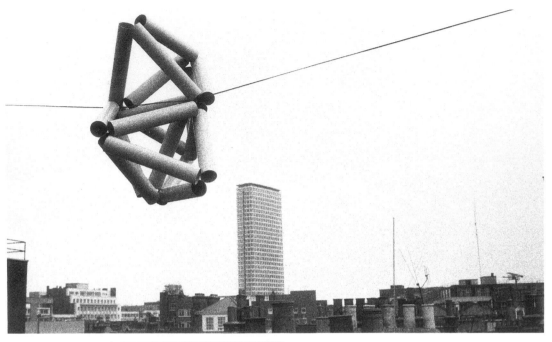

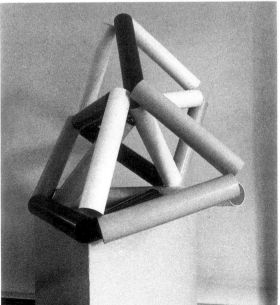

*CO-STRUCTURE 1,
VERSION 1, HOMMAGE A
ROBERTO FRUCHT,* 1970
Plastic tubing
(Not exhibited)

*CO-STRUCTURE 2,
VERSION 1, NO. 3*
Plastic tubing
Unit length 15″
(Not exhibited)

**5B. Parity Studies**

80. *PARITY STUDY THEME 1*
    1969
    Engraved plastic, 40 x 40"

81. *PARITY STUDY THEME 2,*
    *FIRST VERSION,* 1970-74
    Paint on perspex, 68⅞ x 67"
    The Arts Council of
    Great Britain

82. *PARITY STUDY THEME 2,*
    *SECOND VERSION,* 1970-4
    Red and green lines painted
    on back of clear plastic on
    white plastic, 69½ x 67"

83. *PARITY STUDY THEME 3*
    1972-3
    Aluminium on plastic
    31¾ x 48 x 1"

84. *PARITY STUDY THEME 3*
    1972-3
    Stainless steel, aluminium,
    anodized black aluminium
    27 x 27 x 1"
    Private Collection

*PARITY STUDY THEME 3*
1972-3
Plastic, aluminium
33 x 33 x 1"
(Not exhibited)

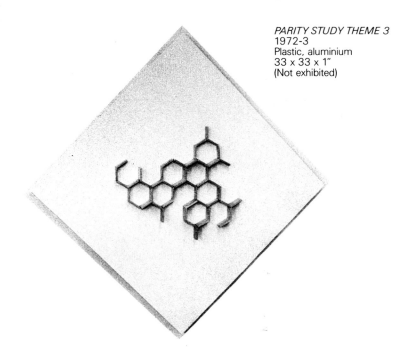

**5C. Compositions with**
**Hexagons ('Perceptual**
**Flipflops')**

85. *HEXOR A,* 1966-76
    Engraved plastic, 23¾ x 23½"

86. *HEXOR B,* 1966-76
    Engraved plastic, 23¾ x 23¾"

87. *HEXOR B COLOURED*
    1966-76
    Engraved plastic, 23¾ x 23¾"

88. *LINEAR CONSTRUCTION B*
    *LARGE RED,* 1972
    Engraved plastic, 24 x 24"
    The Arts Council of
    Great Britain

89. *LINEAR OBSTRUCTION*
    1972-7
    Relief and engraved plastic
    48 x 48"

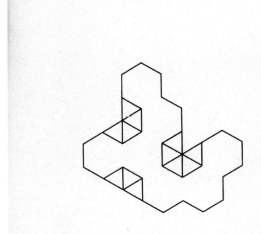

88. *LINEAR CONSTRUCTION B*
    *LARGE RED,* 1972
    Engraved plastic, 24 x 24"
    The Arts Council of
    Great Britain

**5D. 'Flat' reliefs in white laminated plastic with permuted units. i) 1975-7, ii) 1978-80**

**i) 1975-7**

90. *THE NINE – HOMMAGE À KHLEBNIKOV,* No 1 1975
Engraved and relief laminated plastic on wood, 34 x 34 x ¾"
The Arts Council of
Great Britain

91. *THE NINE – HOMMAGE À KHLEBNIKOV,* No 2 1976
Engraved and relief laminated plastic on wood
36 x 36 x ¾" (octagonal)

92. *KUPKA'S TOWER,* 1976-7
Laminated plastic, 34 x 31½"
Mrs Adrian Heath

93. *LINEAR REBIS,* 1976-7
Laminated plastic
31⅞ x 29⅞"

94. *FAST REBIS,* 1976-79
Laminated plastic, 28 x 38"

95. *LARGE REBIS,* 1976-7
Laminated plastic, 31½ x 34"

91. *THE NINE – HOMMAGE À KHLEBNIKOV,* No 2 1976
Engraved and relief laminated plastic on wood
36 x 36 x ¾" (octagonal)

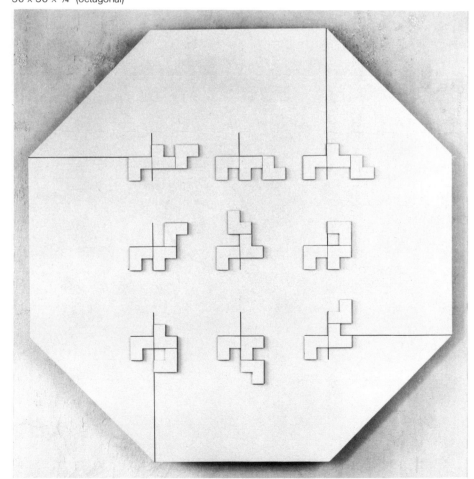

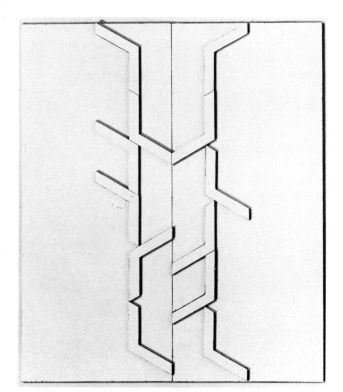

*KUPKA'S TOWER,* 1976-7
Laminated plastic
Model
(Not exhibited)

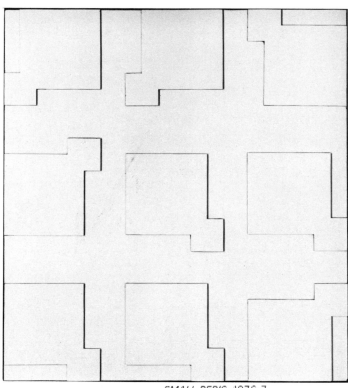

*SMALL REBIS,* 1976-7
Laminated plastic, 23 x 21"
Museum of Modern Art, Lodz
(Not exhibited)

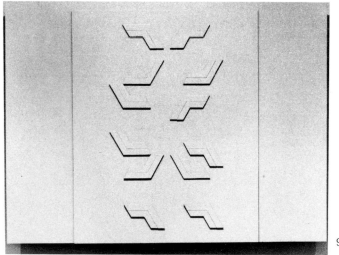

94  *FAST REBIS,* 1976-79
Laminated plastic, 28 x 38"

## ii) 1978-80

96. *INGINE 1,* 1978-9
Laminated plastic
33¼ x 20¼"
Chris and Uta Frith

97. *INGINE 2,* 1979
Laminated plastic, 36 x 36"

98. *CHANGING FORMACT A*
1978-9
Laminated plastic, 33 x 33"
Atlantic Richfield Collection

99. *CHANGING FORMACT B*
1978-9
Laminated plastic, 35 x 35"

100. *THE SIX,* 1978-80
Laminated plastic, 17 x 31½"

101. *LINEAR FORMACT*
1978-79
Laminated plastic, 36 x 28"
Knoedler Gallery, London

102. *TURMACH 3,* 1980-82
Laminated plastic, 24 x 40"

103. *TURMACH 4,* 1980-82
Laminated plastic, 24 x 40"

104. *PROPOSITION AB FOR
AN M,* 1980
Zinc, aluminium, foam-rubber
42¼ x 30 x 2"

105. *PROPOSITION AB FOR
AN M,* 1979-80
Zinc, plastic, foam-rubber
30 x 30 x 6¼"

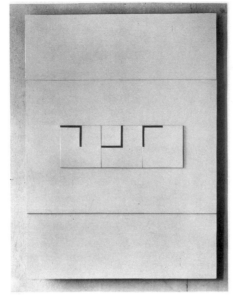

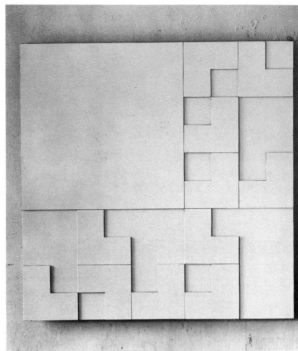

101.
*LINEAR FORMACT*
1978-79
Laminated plastic
36 x 28"
Knoedler Gallery, London

99.
*CHANGING FORMACT B*
1978-9
Laminated plastic
35 x 35"

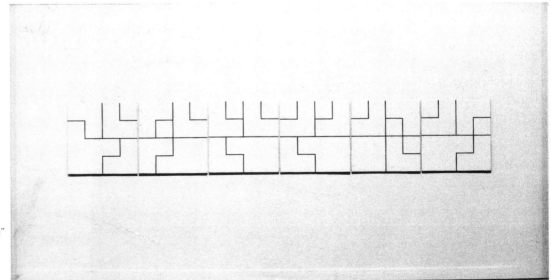

100.
*THE SIX,* 1978-80
Laminated plastic, 17 x 31½"

96. *INGINE 1,* 1978-9
Laminated plastic
33¼ x 20¼"
Chris and Uta Frith

102. *TURMACH 3,* 1982
    Plastic laminate
    24 x 40"

104. *PROPOSITION AB FOR*
    *AN M,* 1980
    Zinc, aluminium, foam-rubber
    42¼ x 30 x 2"

105. *PROPOSITION AB FOR*
    *AN M,* 1979-80
    Zinc, plastic, foam-rubber
    30 x 30 x 6¼"

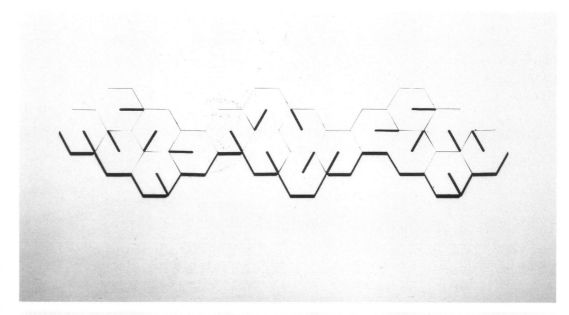

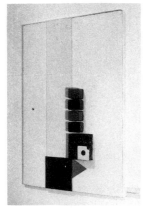

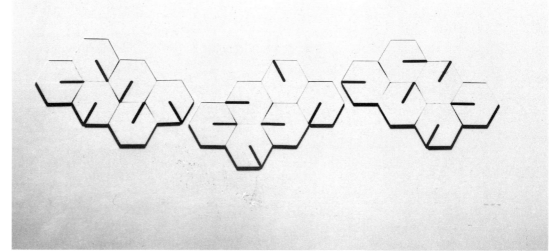

103. *TURMACH 4,* 1982
    Plastic laminate
    24 x 40"

66

**6. Recent Works**

107. *UNTITLED,* 1982
Laminated plastic
36 x 36" (octagonal)

108. *TRIPTYCH* (Study), 1980-82
Laminated plastic
13½ x 19½"

109. *UNTITLED,* 1980-82
Laminated plastic, 21 x 23"

110. *UNTITLED,* 1981-82
Laminated plastic, 30 x 30"

108. *TRIPTYCH* (Study), 1980-82
Laminated plastic
13½ x 19½"

## BIOGRAPHICAL NOTES

Born London 23 April 1930.

Educated at The Downs Preparatory School and Bryanston School.

### 1947-51

St Martins School of Art 1947-9.

Central School of Art and Crafts 1949-51 where he met Victor Pasmore and Robert Adams.

### 1950

Meets Kenneth and Mary Martin and Adrian Heath. With these artists and Pasmore and Adams, starts to play an active part in the formation of a constructed abstract art group in London.

Makes first of annual visits to Paris where he meets, among other artists, Vantongerloo, Picabia, Kupka, Sonia Delaunay, Michel Seuphor and the English artist Stephen Gilbert.

Shows first work in public at opening of the Dover Street premises of I.C.A. *(Aspects of British Art,* 13 December 1950 – 12 January 1951).

### 1951

Living at 3 Neville Street, South Kensington and at Midhurst, Sussex.

Spring. Starts to correspond with Marcel Duchamp.

June 7. Receives first letter from Max Bill. Correspondence continues sporadically until July 1960.

May-June. On the organising committee of the exhibition of *Abstract Paintings, Sculptures, Mobiles,* at the A.I.A. Gallery and contributes to *Broadsheet,* published in connection with this exhibition.

August. Organises the exhibition *British Abstract Art* at Gimpel Fils Gallery.

### 1952

January 2. Receives first letter from Charles Biederman. Correspondence continues until 1960-61.

Plays an active part in organising weekend exhibitions of abstract art at Adrian Heath's studio, 22 Fitzroy Street.

June. In *Broadsheet No. 2* publishes an explanation and defence of *Concrete Art.*

July. In Paris purchases Duchamp's *Green Box.* Kupka gives him a copy of the set of wood engravings *'Quatre Histoires de Blanc et Noir'* (Paris 1926).

### 1953

Living at 107 Queen's Gate, London, SW3 and later at Sloane Court, SW3.

Publishes an article on Max Bill with Bill's collaboration.

May. Active in 3rd weekend exhibition at 22 Fitzroy Street.

### 1954

By March at 4 Hunter Street, London, WC1.

In May meets John Ernest at the exhibition *Artist versus Machine.*

Contributes to the book *Nine Abstract Artists,* a collection of essays produced by the London Constructionists and their associates.

### 1955

January. Shows first constructed relief in plastic at the exhibition *Nine Abstract Artists* at the Redfern Gallery, London.

September. Works in studio at 18 Greek Street, Soho.

Starts to teach part-time in the Art School of the Regent Street Polytechnic. Continues until 1963.

**1956**

During the winter of 1955-6 makes his last paintings and then commits himself to relief-constructions.

August. With John Ernest and Denis Williams is responsible for a section at the exhibition *This is To-morrow* at the Whitechapel Art Gallery, London.

**1957**

August. Takes a room at 24 Charlotte Street, London, W1.

December. Contributes to the exhibition *Dimensions, British Abstract Art 1948-57* at the O'Hana Gallery, London.

Works as clerk in the British Museum Library through summer.

**1958**

February 12 — March 8. Holds one man exhibition of *Recent Constructions* in the library of the Institute of Contemporary Arts.

Summer. Through Charles Biederman, meets Gillian Wise, with whom he collaborates in subsequent years.

First meeting with Guy de Bord and Michèle Bernstein — founders of *L'International Situationisme*.

**1959**

Meets Marcel Duchamp and publishes an article on him.

First visit to Holland, where he meets the artists Joost Baljeu and Karel Visser and the mathematician Brouwer.

Starts to contribute articles to *Structure*, Baljeu's international journal of constructionist art.

**1960**

June. At the invitation of Max Bill exhibits at the exhibition of *Concrete Art* in Zurich. This is the start of much more extensive exhibiting abroad.

**1961**

January. Shows at *Construction England: 1950-1960* at the Drian Gallery, London, which is almost the last group manifestation of the London *Constructionists*.

July. Contributes a large mural-relief to the Congress Building of the International Union of Architects on the South Bank. Introduces planes at 45° thus breaking what had been exclusively orthogonal constructions.

Exhibits extensively on the Continent.

**1962**

May. Shows seven reliefs at *Experiment in Constructie*, Stedelijk Museum, Amsterdam.

**1963**

February. Shared exhibition, with Gillian Wise, at the Institute of Contemporary Arts.

Publishes his first mathematical paper. (Co-author with Frank Harary.)

Arts Council of Great Britain purchases first work.

Tate Gallery purchases first work.

Starts (or possibly in previous year) to use aluminium sections of 60° and 120°.

**1964**

Starts to teach part-time at Chelsea School of Art.

First visit to U.S.A. Meets Bourgoyne Diller, Charmion Von Wiegand, Don Judd, Ad Reinhardt, talk at M.I.T. at invitation of Kepes.

**1966**

October. One-man exhibition at Kasmin Gallery, London.

**1967**

Invited speaker at Fylkingen's Stockholm International Festival on Art & Technology (John R. Pierce, Oskar Hausen, Yona Friedman, Ianis Xenakis, etc.)

**1968**

Shows in the exhibition *Plus by Minus: Today's Half-Century*, Buffalo; *Relief/Construction/ Relief*, Chicago; *Documenta 4*, Kassel.

Visits Czechoslovakia.

Edits *DATA*, an anthology of essays by contemporary artists, architects and scientists.

**1969**

April. British section of the exhibition of *Konstruktive Kunst*, Nurenberg.

October. One-man exhibition at Kasmin Gallery, London.

Visits the U.S.S.R. In Moscow meets Dvijenie Group (Lev Nusberg and the N.E.R. group of architects.)

**1971**

Awarded a Leverhulme Research Fellowship, for research in the perception of abstract symmetry and asymmetry.

**1973-4**

Starts REDO. Collages and reliefs, often erotic, of material assembled from pulp magazines, cultural hand-outs and other sources. The name is a contraction of Rem Doxfod.

**1974**

Culmination of research on Mondrian's compositions. Results published by Frieder Nake.

**1976**

With Gillian Wise-Ciobotaru, Kowolski, Friedman and Snelson shows with the *Art Research Syndicate*.

**1977**

August. Shows eight works at the exhibition of *Current British Art*, at the Hayward Gallery.

**1978**

Marries Yuriko Kaetsu.

**1980**

May. Exhibits in *Pier and Ocean*, Hayward Gallery.

November. One-man exhibition (with REDO) of recent work at Knoedler Gallery, London.

**1981**

Visits Poland and participates in the exhibition *Construction in Process in the Art of the Seventies*, at Lodz.

**LIST OF EXHIBITIONS**

**1950**
December 13 – January 12 1951. *Aspects of British Art,* Institute of Contemporary Arts, Dover Street, London. (No. 16)

**1951**
February – March. *London Group.* (No. 170)
May 22 – June 11. *Abstract Paintings, Sculptures, Mobiles,* Artists' International Association. (Nos. 12, 26)
August. *British Abstract Art,* Gimpel Fils Gallery, London. (No. 28)

**1952**
March 21 – 23. *Abstract Paintings, Constructions, Sculpture, Mobiles,* at Adrian Heath's studio, 22 Fitzroy Street, London.
July 11 – 14. Second exhibition of *Abstract Works,* at 22 Fitzroy Street. (3 exhibits)
July – August. *7th Salon des Réalités Nouvelles,* Paris. (1 exhibit)
December 2 – 20. *The Mirror and the Square,* Artists' International Association. (No. 134)
*Collages and Objects,* Institute of Contemporary Arts. (2 exhibits)

**1953**
May 1 – 4. Third exhibition of *Abstract Works,* at 22 Fitzroy Street. (4 exhibits)
*Collectors' Items,* Institute of Contemporary Arts, (2 exhibits)

**1954**
May 19 – June 9. *Artist versus Machine,* Building Centre, Store Street, London. (1 exhibit)
October 13 – June 9. *Collages and Objects,* Institute of Contemporary Arts. (Nos. 57, 58)
*Collectors' Items,* Institute of Contemporary Arts. (1 exhibit)

**1955**
January 11 – 29. *Nine Abstract Artists,* Redfern Gallery, London. (Nos. 13, 14 and one exhibit ex-catalogue)
May 10 – 29. *Measurement and Proportion,* Artists' International Association. (Nos. 11, 20)

**1956**
January 2 – 27. *Aspects of Contemporary English Painting,* Parsons Gallery, London. (No. 28)
August 8 – September 9. *This is To-morrow,* Whitechapel Art Gallery, London. Section V with John Ernest and Denis Williams.
December 3 – 20. *Recent Abstract Painting,*
Whitworth Art Gallery, Manchester. (Nos. 28, 29, 30)
*English Graphic Art,* California Institute of Technology. (2 exhibits)

**1957**
January 16 – February 16. *Statements – a review of British abstract art in 1956,* Institute of Contemporary Arts. (No. 12)
March. *Cinquante ans de peinture abstrait,* Galerie Creuze, Paris. (No. 164)
May 6 – 26. *English Abstract Art,* Artists' International Association. (No. 4)
July 23 – September 1. *Living Art,* Lords Gallery, London. (No. 19)
November 6 – 30. *Pictures without Paint,* Artists' International Association. (Nos. 18, 19)
December 6 – 21. *Dimensions, British Abstract Art 1948-57,* O'Hana Gallery, London. (Nos. 30, 31, 32)

**1958**
February 12 – March 8. *Recent Constructions,* Institute of Contemporary Arts. A one man exhibition of 8 constructed reliefs.

**1959**
July 8 – August 9. *E.C. Gregory Memorial Exhibition,* Institute of Contemporary Arts. (No. 51)
August 6 – September 6. *Paintings, Drawings, Reliefs,* Artists' International Association. (No. 10. 2 exhibits)

**1960**
January. *Drian Artists,* Drian Gallery, London (1 exhibit)
June 8 – August 14. *Konkrete Kunst,* Helmhaus, Zurich. (No. 129)

**1961**
January 11 – February 4. *Construction: England: 1950-1960,* Drian Gallery. (Nos: 18, 20, 22, 27)
July. *International Union of Architects Congress building,* South Bank, London. (Mural-relief)
*2 ième Biennale de Paris.* (3 exhibits)
September 1962. *British Constructivist Art,* a touring exhibition in the U.S.A. arranged by the Institute of Contemporary Arts and the American Federation of Artists (Nos. 19-24) (And toured in 1963 in Great Britain by the Arts Council under the title *Construction England).*

## 1962

January — February. *Art Abstrait Constructif International*, Galerie Denise René, Paris. (1 exhibit)
May 18 — June 16. *Experiment in Constructie*, Stedelijk Museum, Amsterdam, (Nos. 34-40)
August 25 — September 30. *Experiment in Fläche and Raum*, Kunstgewerbe Museum, Zurich. (Nos. 34-38)
*Konstruktivisten*, Städtisches Museum, Leverkusen.
*Constructivisme*, Galerie Dautzenberg, Paris. (1 exhibit)
*27 Artistes Constructifs*, Galerie d'Art Moderne, Basle. (1 exhibit)
*Collages and Constructions*, Aldeburgh Festival.

## 1963

February. Shared exhibition with Gillian Wise, Institute of Contemporary Arts. (Nos. 1-12)
*4th San Marino Biennale, Oltre L'Informale*. (3 weeks).
*Esquisse d'un salon*, Galerie Denise René, Paris.
*British Art*, Stone Gallery, Newcastle-upon-Tyne.
*Painters' Collections*, Leicester Gallery, London.
*Drawings*, New Vision Centre, London.

## 1964

April 22 — June 28. *Painting and Sculpture of a Decade, 1954-64*. Organised by the Calouste Gulbenkian Foundation at the Tate Gallery, London. (Nos. 321, 322)
*Contemporary British Painting and Sculpture*, Albright Knox Gallery, Buffalo.
*Profile 3 Englische Künstler*, Städtische Kunstgalerie, Bochum.

## 1965

*British Sculpture '60's*, Tate Gallery.
*A Collection in the Making, The Peter Stuyvesant Collection*, Whitechapel Art Gallery.
*Art and Movement*, Tel Aviv Museum.
*8th Tokyo Biennale*.

## 1966

14 October — November. *One man exhibition of a selection of work from 1956-66*, Kasmin Gallery, London.
*Sigma 1, Recherche et d'action culturelle*, Bordeaux.

## 1967

*Sigma II*, Bordeaux.
*Unit, Series, Progression*, The Arts Council Gallery, Cambridge.

15 November — 22 December. *Recent British Paintings, The Peter Stuyvesant Foundation Collection*. (Nos. 56, 57, 58)

## 1968

*Klub Konkretistu*, Spalova Gallery, Prague, C.S.S.R.
*Plus by Minus: Today's Half Century*, Albright Knox Gallery, Buffalo.
October 26 — December 1. *Relief/Construction/Relief*, Museum of Contemporary Art, Chicago. (Nos. 28-31)
November 15 — December 15. *Art and the Machine*, University of East Anglia, Norwich. (No. 45)
*Documenta 4*, Kassel. (4 exhibits)

## 1969

April 18 — August 3. *Konstruktive Kunst: Elemente und Prinzipien*, Biennale Nürnberg. (5 exhibits)
*10th Middleheim Biennale of Sculpture*.
*Four Artists: Reliefs, Constructions and Drawings*, Victoria and Albert Museum, London and Spain. (A touring exhibition.) (Hill, Ernest, Wise, Hughes)
October 15 — November 8. *One man exhibition of recent work*, Kasmin Gallery, London.
*Konstructivismens Arv*, Sonja Henie Niels Onsted Foundation, Norway and at the Bellahy Centre, Copenhagen. (Nos. 63-67)

## 1972

July 6 — September 8. *The Non-Objective World 1939-1955*, Annely Juda Fine Art, London. (Nos. 83, 84, 85)

## 1973

July 5 — September 22. *The Non-Objective World 1914-1955*, Annely Juda Fine Art. (Nos. 58, 59)
28 September — 17 November. *From Henry Moore to Gilbert and George, Modern British Art from the Tate Gallery*, Tate Gallery, London and Palais des Beaux Arts, Brussels. (No. 71)

## 1974

January 23 — February 15. *Tables*, Garage Gallery, Earlham Street, London. (1 screen)
August 17 — September 14. *Aspects of Abstract Painting in Britain, 1910-1960*, Talbot Rice Art Centre, University of Edinburgh. (Nos. 25-30)
September 26 — November 17. *British Painting '74*, Arts Council of Great Britain, Hayward Gallery, London. (Nos. 82, 83)

## 1975

January 15 — 23. *Art Fair*, Contemporary Art Society, London. (No. 58)

February – May. *Cuatro artistas britanicos,* Gerona, (Nos. 9-16)

June 18 – June 23. *British Art '75,* Basle. (No. 22)

*Sculpture at Greenwich.* (1 exhibit)

November – December. *New Work I,* A.C.G.B., Hayward Gallery, London. (Nos. 1-8)

**1976**

February 21 – March 20. *Rational Concepts: English Drawings,* Kunstcentrum "Badhuis", Gorinchem, Holland.

February – May. *Arte Inglese Oggi,* Palazzo Reale, Milan. (10 works)

May 6 – August 8. *John Moore's 10th Exhibition,* Walker Art Gallery, Liverpool. (No. 64)

July 10 – August 15. *De Volle Maan,* Stedelijk Museum "Het Prinsenhof" Oude Delft, Delft.

*A.R.S. Roadshow,* Conduit Gallery, Imperial College and North London Polytechnic (touring)

**1977**

July 20 – September 4. *Current British Art, The Hayward Annual Part 2,* A.C.G.B. Hayward Gallery. (Nos. 138 – 145)

September 24 – November 20. *British Painting 1952-1977,* Royal Academy of Arts, London. (Nos. 174-176)

*The Tradition of Geometric Art,* selected items from the McCrory Corp. Collection, M.O.M.A., Paris

**1978**

March. *The Museum of Drawers,* The Cooper-Hewitt Museum, New York, and I.C.A. (London) (touring)

March 29 – April 19. *Constructive Context,* Artists' Market Association, Warehouse Gallery, Covent Garden. Toured by the A.C.G.B. until March 1979.

**1979**

*The Open & Closed Book,* Victoria & Albert Museum.

*Evolution of the Constructed relief 1913-1979,* University of Saskatoon, Canada. (2 works from the Lipschultz Collection, Chicago)

**1980**

April 21 – June 27. *Geometry as Abstract Art: The Third Generation,* selections from the Lipschultz Collection, Swen Parson Gallery, Northern Illinois Univesity, Dekalb, Illinois. (2 exhibits)

May 8 – June 22. *Pier and Ocean, construction in the art of the '70's.* A.C.G.B., Hayward Gallery, London; (Then July 13 – September 8 at the Rijksmuseum Kröller-Müller, Otterlo, Holland). (3 exhibits)

November. *One man exhibition of recent work (with REDO),* Knoedler Gallery, Bond Street, London.

**1981**

October. *Construction in Process in the art of the seventies,* Stowarzyszenie Tworcow Kultury, Lodz, Poland.

November. *British sculpture in the 20th century. Part II 1951-1980 'Symbol & Imagination',* Whitechapel Art Gallery. (Section VI, No. 61)

**1983**

February. *Concepts in Construction 1910-1980,* organised by Independent Curators Incorporated, Tyler Museum, Texas and travelling. (1 exhibit)

## BIBLIOGRAPHY

Publications by * and concerning Anthony Hill (excluding mathematics papers)
* marked thus.

### 1951

*Mobiles and Alexander Calder, Broadsheet No. 1, devoted to Abstract Art,* June, Lund Humphries, London.*

Work reproduced in *Réalités Nouvelles, Album 5,* June, Paris, 58.

Introduction, *Hugh Townley — Sculpture,* Apollinaire Gallery, July, London.*

Introduction, *Robert Adams — Sculpture,* Gimpel Fils Gallery, July, London.*

Toni del Renzio, *First Principles, Last Hopes, Typographica* 4, n.d., 14-20.

### 1952

*Concrete Art. An Introductory Note, Broadsheet No. 2,* June, London.*

### 1953

*Max Bill, the search for the unity of the plastic arts in contemporary life, Typographica,* 7, n.d., (New Year), 21-28.*

R.V. Gindertael, *Peintres Britanniques d'Aujourd'-hui, Art d'Aujourd'hui,* Series 4, ii, March, 12-15

### 1954

L. Alloway, *Arte non-figurative inglese, Arti Visive,* 6-7, Roma, January.

L. Alloway (introd.), *Nine Abstract Artists,* London, December. Statement by Hill, 27-28.*

### 1955

Unsigned foreword in the catalogue, *Nine Abstract Artists,* Redfern Gallery, January.*

H. Wescher, *Londres, Notes de Voyage, Cimaise,* Series 2, iii, January — February, 5.

### 1956

L. Alloway (Introduction), *This is To-morrow,* Whitechapel Art Gallery, August. Introduction to Section V by Hill.*

R. Banham, *This is To-morrow, Architects' Journal,* August 16, 217-221.

Theo Crosby, *This is To-morrow, Architectural Design,* October, 334-336.

*The Constructionist Idea and Architecture. Ark,* the Journal of the Royal College of Art, 18, November, 24-29.*

### 1957

*Statements — a review of British abstract art in 1956,* I.C.A., January. Statement.*

M. Seuphor, *Dictionaire de la Peinture Abstrait,* Paris.

*Charles Biederman and Constructionist Art, Broadsheet No. 3,* December.*

### 1958

L. Alloway (Introduction), *Recent Constructions,* I.C.A., February.

### 1959

M. Seuphor, *Sculpture of this Century,* Neuchatel.

*Kalte Kunste — a manifesto?, Art News and Review,* XI, v, March 28, 5 and 14.* (Review of *Kalte Kunst? —* by Karl Gerstner, Zurich, 1957).

*Introducing "Structure", Art News and Review,* XI, xii, July 4, 2 and 10.*

*Duchamp, Art News and Review,* XI, xx, October 24, 6.*

Letter to the *Listener* on *Art — anti — art,* LXII, no. 1601, December 3, 980.*

*On Constructions, Nature and Structure, Structure,* Series 2, i, 4-8.* (Republished in S. Bann (ed.), *The Tradition of Constructivism 1920-64,* 1974, 268).*

### 1960

*Movement in the domain of the static construction, Structure,* series 2, ii, 58-61.*

*Exegis, Polygon,* Journal of the Architecture Department of the Regent Street Polytechnic.*

*O Konstrukcijama, Prirodi i Strukturi, Čovjek i prostor,* God vii, no. 104, Zagreb, Studeni.*

## 1961

*Art and Mathematics – a Constructionist View, Structure,* series 3, ii, 59-63.*

L. Alloway, *London Letter, Art International,* V, ii, March, 46.

*The Questions of Synthesis, Collaboration and Integration occasioned by the I.U.A. Congress Headquarters Building, Structure,* series 4, i, 18-22.*

A. Bowness, *Art and Architecture, Arts,* XXXV, x, 62-65.

T. Crosby, *Experiment in Integration, Architectural Design,* XXXI, xi, November, 482-509. Statement, 504.*

## 1962

H. Janis and S. Blesch, *Collage,* New York, 235, 240.

*Some reflections on Modern Art, Structure,* series 4, ii, 46-48.*

*Art and Society, Structure,* series 5, i, 19-24.*

Discussion on *Vantongerloo* with Jasia Reichardt and John Golding on BBC 3rd Programme.* November.

*R.P. Lohse,* Zurich.*

## 1963

J.P. Hodin, *Documentation on Anthony Hill, Quadrum,* 14, 140-141.

N. Lynton, *London Letter, Art International,* VII, iii, 55.

Statement in *Anthony Hill/Gillian Wise,* catalogue of joint exhibition at the I.C.A., London.*

## 1964

*Interim Thoughts, Structure,* series VI, i, 17-22.*

H. Read, *Contemporary British Art,* Harmondsworth.

## 1965

*Constructed Art,* in D. Lewis (ed.), *The Pedestrian in the City, Architects Year Book,* XI, London, 41-43.*

J. Russell, *Private View,* London.

## 1966

*Constructivism – the European Phenomenon, Studio International,* 171, no. 876, April, 140-147.*

J. Ernest, *Constructivism and Content, Studio International,* 171, no. 876, April, 148-156.

*The Structural Syndrome in Constructive Art,* in G. Kepes (ed.), *Module, Proportion, Symmetry, Rhythm, Vision and Values,* series no. IV, New York.*

Kenneth Frampton, *Anthony Hill interviewed by Kenneth Frampton, Studio International,* 172, no. 882, 200-201.*

## 1967

*A Plastician's view of art and technology, Fylkingen International Bulletin,* I, Stockholm, 26-32.*

A. Pellegrini, *New Tendencies in Art,* London.

G. Rickey, *Constructivism, Origins and Evolution,* New York.

## 1968

*Art and Mathesis: Mondrian's Structures, Leonardo,* I, iii, July, 233-242.*

A. Hill (ed.), *DATA, Directions in Art, Theory and Aesthetics: An anthology,* London, 1968. *Programme, Paragram, Structure,* 251-265.*

A. Bowness, *Contemporary British Painting,* London.

D. Lewis (ed.), *Urban Structure,* Architects Year Book, XII.

F. Popper, *Kinetic Art,* London.

A. Grieve, *Art and the Machine,* University of East Anglia, Norwich.

## 1969

*The Climate of Charles Biederman, Studio International,* 178, no. 914, September, 68-70.*

Stephen Bann, *The Centrality of Charles Biederman, Studio International,* 178, no. 914, September, 71-74.

Statement by Anthony Hill in *Four Artists: Reliefs, Constructions and Drawings.* Victoria & Albert Museum touring exhibition.*

## 1970

*Facts before studies,* (review of books on Kupka, Lissitzky, Malevich, etc.). *Leonardo,* III, i, January, 105-108.*

*Some Problems from the Visual Arts, Annals New York Academy of Science,* 175, Art I, July, 208-223.*

*A Structuralist Art?, Twentieth Century Studies,* III, May, 102-109.*

W. Feaver, *Read Paint, London Magazine,* X, iii, June, 39.

*Ars Combinatoria, The Sciences,* N.Y.A.S., X, vii, July.

*Vytvarné Uměni,* 9/10, Prague.

## 1971

M. Holt, *Mathematics in Art,* London, 69-71

Review of M. Holt, *Mathematics in Art, Leonardo,* IV, iv, 395, 396.*

*Cubism,* review of J. Slothouber and W. Gratsma, *Cubic Construction, Architectural Design,* XLI, March, 181.*

Review of J. Cousin, *Topological Organisation, Architectural Design,* XLI, November, 715.*

## 1972

*Desiderata (1971), Studio International,* CLXXXIII, no. 944, May, 204-206.*

Letter replying to Holt, *Leonardo,* V, ii, Spring, 191.*

J. Reichardt, *Art at large, The New Scientist,* 55, no. 803, July 6, 51.

## 1973

M. Ragon and M. Seuphor, *L'Art Abstrait,* Galerie Maeght, Paris.

Review of C. Bragdon, *Projective Ornament* and O. Whicher, *Projective Geometry, Leonardo,* VI, i, Winter, 77-79.*

## 1974

S. Bann, *The Constructivist Tradition, Documents of 20th century art,* London.*

*A note on Basically White* (review), *One,* iv, July.*

F. Nake, *Mondrian Strukturel – Topologische,* in *Asthetik als Informations Verarbeitung,* Vienna (uses results of Hill's research into Mondrian's compositions).

## 1975

*Introducing Yona Friedman, Royal Institute of British Architects Journal,* 3, 105.

*The Spectacle of Duchamp, Studio International, Duchamp Supplement,* 189, no. 973, January/ February, 20-22.*

## 1976

*De Volle Maan, Stedelijk Museum "Het Prinsenhof",* Delft. Statement.*

H. Osborne, *Non-Iconic Abstraction, The British Journal of Aesthetics,* XVI, iv, Autumn, 291-305.*

R.C. Kenedy, *Anthony Hill, Art International,* XXI, 8-9, October-November, 34-38, 64, 65.

C. Phillpot, *Müvészet, A Magyar Képzômüvészek szövet Ségének Lapja,* XVII, xi, Budapest, November.

*Report of the Trustees of the Tate Gallery for 1968-70,* 88.* Statement of 27 July 1970 on the Cambridge screens.

F. Crichton, *London Letter, Art International,* XXI, 1-2, January/February, 52.

## 1977

W. Rotzler, *Constructive Concepts,* A.B.C. eds., Zurich.

C. Naylor and G.P. Orridge, *Contemporary Artists,* London, St. James' Press. Statement by Hill and biography by F. Crichton, 406, 407.*

*A view of Non-figurative Art and Mathematics and an analysis of a structural relief, Leonardo,* X, i, 7-12.*

Review of F.A. Wilson, *Alchemy as a Way of Life, Leonardo,* X, iii, 243-244.*

A. Brighton and L. Morris (eds.), *Towards Another Picture, An Anthology of Writings by Artists Working in Britain 1945-1977,* Nottingham, 1977 107-110.*

## 1978

*Tate Gallery Illustrated Catalogue of Acquisitions 1974-76*, 109-111.* Statements by Hill on T. 1906, T. 1907, T. 2027.

Letter by Rem Doghsvaat, *Art Monthly*, xvii, 24.*

*Where Art is Now*, *Art Monthly*, xviii, 18, 19.*

Review of *Kenneth Martin* exhibition at Waddington Gallery, *Art Monthly*, xviii, 27.*

*Constructive Context*, an exhibition selected from the Arts Council Collection by Stephen Bann, London. Statement by Hill, 22.*

## 1979

H. Osborne, *Abstraction and Artifice in Twentieth Century Art*, Oxford.

F.J. Malina (ed.), *Visual Art, Mathematics and Computers*, introduction by Hill, Oxford.*

## 1980

S. Bann, *Abstract Art — A Language? Towards a New Art*, Tate Gallery.

*Autoscopy*, *Art Monthly*, xxxix, 30.

## 1981

H. Osborne, *The Oxford Companion to 20th Century Art*, Oxford, 1981, 257, 258.

*Visual Direction of Art*, N.Y., 1981.

## 1982

K. Frampton, *Neoplasticism and Architecture: Formation and Transformation*, in *De Stijl, 1917-31. Visions of Utopia*, Oxford, 1982, 116.

## PUBLIC COLLECTIONS

Arts Council of Great Britain

Basildon Arts Trust

British Council

British Museum

University of East Anglia Art Collection

Calouste Gulbenkian Foundation

City Art Gallery, Huddersfield

Leicester Education Authority

Museum of Modern Art, Lodz, Poland

McCrory Foundation, U.S.A.

Whitworth Art Gallery, Manchester

Rijksmuseum Kröller-Müller, Holland

Scottish National Gallery of Modern Art, Edinburgh

City Art Gallery, Southampton

Victoria and Albert Museum, London

Tate Gallery, London

## RAW MATTERS
Anthony Hill

Some years ago John Myhill asked me if I knew I had been described in a book he'd read as having given up painting for geometry! In fact what it said was that I had given up painting for *geometrical construction.*

The abdication might be said to date from 1958 when I had my first one-person exhibition 'Recent Constructions' at the ICA. The introduction in the catalogue was written by Lawrence Alloway. The only response came, not from another art critic, but an unsigned piece in the Architect's Journal which said that while they were being described as 'tin Pasmores' behind my back, architects could do well to take a look at how industrial materials can be combined to good effect. Alloway referred only to Gabo and Pevsner noting that for them Constructivism meant something monumental whereas I was not aiming at that kind of thing. Of course, the real influences were Tatlin, Pasmore and Biederman.

Tatlin's abstract relief constructions were made between 1914 and 1922; Biederman was making reliefs from 1936 onwards, and Pasmore, who started to make reliefs in 1951, was the first English artist to be influenced by Biederman. After he returned to painting Pasmore said his aim was to arrive at a synthesis of the formal and informal approaches in abstract art.

Biederman's approach embraces a number of component ideas, only one of which took hold of me, the belief that painting and sculpture had run their course. I found this to be essentially the view of Marcel Duchamp who of course arrived at it much sooner and from quite a different point of departure.

The belief has remained with me ever since (with some modifications). I also believe, along with many other artists, that abstract art remains the only entirely valid development in 20th century art and I can think of few artists who have not been influenced by *some* aspect of abstract art.

But equally the discovery that art at the same time must undergo the most severe 'philosophical' scrutiny has brought about an entirely new climate . . . art has become exposed, naked (never mind the various new enclothings).

We read that *Modernism* has at last collapsed, but whether this idea came first from artists or art writers is a good question. *The death of Fine Art* was first proposed by members of the Soviet avant garde at roughly the same time as the advent of Dada.

From then on others have proposed what it is that should follow. Meanwhile we now live in a millenial climate of hectic pluralism and as to whether this is healthy or not there are of course radically conflicting opinions.

Radical art? Today it is either radical because of the external character of the subject matter and handling of the media (as in Expressionisms) or because it is not *painting* or *sculpture* but concept art, land art, . . . body art, performance art . . . or simply photography and/or video.

As long ago as 1925 the main point of departure for what I and some other artists do today was put thus by Arp and Lissitzky in their *'Isms of art'.* "Constructivism: these artists look at the world through the prism of technique — they don't want to give an illusion by means of contours on canvas, but work directly in iron, wood, glass, etc. The shortsighted see therein only the machine. Constructivism proves that the limits between mathematics and art, between a work of art and a technical invention are not to be fixed".

So artists of my generation were presented with a new terrain plus various paths, and some of us have been mapping the terrain and travelling some of the paths.

As it went to press, the most recent 'ism' and the last to be described by Arp and Lissitzky was *abstract film* about which they wrote:

"Like modern painters and sculptors nowadays the film also begins to unfold and form its specific material: movement and light".

It is difficult to understand exactly why the Constructivists in Russia did not contribute to the beginnings of *abstract cinema* which today remains the most neglected of all the on-going 'isms' of modern art.

In May 1974 I was nominated for an artist-in-residence Deutscher Akademischer scholarship. to make a film, an abstract film. The application was turned down on the grounds that I was too well known to be *unknown* and not well enough known to be *well known*. In 1976 Gillian Wise-Ciobotaru applied to the Arts Council for a grant so that Martin Dodds, a graduate of the R.C.A., could proceed with a film about a group of artists, including Kenneth Martin, in which were to appear some short sequences made by each. The Nuffield Foundation was unable to help when I wrote to them hoping to be able to pursue my own projected film sequence (October '79). Rescue came from Canterbury School of Art, Ralph Rumney and Toni del Renzio who at that time were on the staff, and some footage was made on my project: *66 Canonic Variations*.

A little later I was corresponding with Ré Soupault on the matter of Viking Eggeling, but when I tried to persuade her to be interviewed on video she declined saying she had had more than enough media exposure for someone of her age and anyway had no more to say.

Abstract film has kept pace with technical developments and the Whitney brothers have demonstrated how computer animation can be put to use there with dazzling effect. However, perhaps not surprisingly, computer animation and stereoscopic cinema have so far been at their most successful structurally in the area of mathematical 'expository' film.

I still remember the impact of the first 'commercial' piece of abstract film, the Bach sequence in Disney's *Fantasia*. Abstract art in a 'dynamic' form had never before been seen by such a vast audience. Since then only in short blasts has the genre been used 'commercially' and then almost solely in advertising. Now, with the video presentation of Pop music much of the repertoire of 'experimental' film is back in business. I look forward to really good 'numbers' being videolized by Ryszard Wasko, Paul Sharit and others.

Does 'abstract' film always require a 'sound' track . . great music (of the past), modern music or Pop? Eggeling and Richter's pioneering pieces were silent although it is significant that Eggeling's was called *Diagonal Symphony* (1924). With colour, form and movement is it not possible to make an abstract (silent) film? I am not looking forward too much to artists taking up, once more, the various attempts to realise some form of synthesis . . . the dream of Wagner, Scriabin and others. (How often the different arts can merge successfully is not of course something to be prescribed or proscribed.) There is Webern, and there is Mondrian, but the equivalent to either, in the domain of film, is yet to come.

The kinds of works I have been making since the middle fifties have included 'mathematical' works, using the adjective to stress the existence of some kind of structured theme or notion or principle of composing. However it would be a mistake to look for this element as an invariant component; often works have been concerned with some physical or perceptual interest.

*66 CANONICAL*
*VARIATIONS*
1981

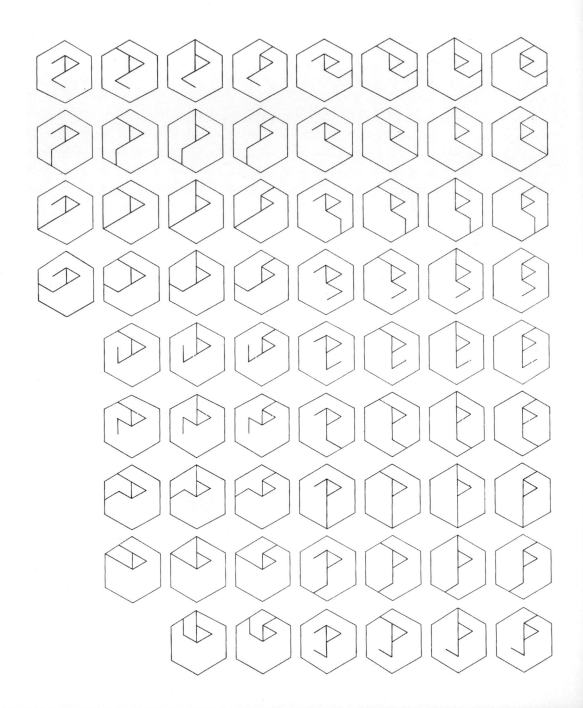

The mathematical ideas were at first the 'classical' concerns of ratio and proportion etc., but then were replaced by purely qualitative ideas (i.e. topological), and what is called in mathematics *constructive enumeration*. All these things first interested me as things in themselves and it was then that I first started asking 'mathematical' questions and tried to come up with some answers.

Moving in quite another direction, amongst my earliest works were collages often using disparate elements, for example, a Pear's soap wrapper replete with small printed image of a pear. In 1950 I sent a photo of one such work for inclusion in the album of the *Réalités Nouvelles* and it was returned with a letter objecting to the writing (printing) and the gratuitous imagery.

I have never lost my interest in juxtaposition and in employing elements that are virtually *found objects* and the *ready-made* element. This interest lay more or less dormant for a long period and then in 1973 I started making collages (and later reliefs) which I signed REDO.

At first the alter ego's name was Rem Doxfod but it was suggested to me by the museum curator Michel Gaudibert that I shorten the name to Re Do and this led me to settling for Redo.

By way of an experiment I have decided to make a different kind of 'separation' towards these works as I have made with the attempts to do mathematics. While I have documented my thirty years of intermittent work in mathematics, the ten years of Redo activity is being exhibited separately[1]

The idea of combining some aspect of Redo work with the constructive reliefs is something that got no nearer than some reliefs I made 1979-80 using kitchen sponges and foam rubber.

To complete this budget of raw matters, what follows is an extract from an interview with Kenneth Frampton made in January 1983 and extracts from pieces by John Myhill, Yona Friedman and Frank Harary, each being distinguished in their own fields and with whom I have, at periods, been closely associated.

[1]Angela Flowers Gallery (May) 1983.

**Questions —**
**Kenneth Frampton.**
Answers —
Anthony Hill.

**After your correspondence with Duchamp and one meeting do you feel you missed actually *knowing him?***

The answer has to be this — I am glad things are no different from what they were. I am a Solipsist . . . people laugh, but my great hero Brouwer was one. I know amongst artists you don't normally hear the word . . .

**To return to your relation to Duchamp it seems to me that you chose mathematics instead of chess. Is this so?**

Yes, and of course it can prove quite embarassing, being anumerative. I am rather shy in the company of a passing mathematician.

**What about the influence of the Dutch mathematician Brouwer?**

By some intuitive source I had already, in 1950, arrived at the conclusion that he was a 'stupor mundi' amongst his generation and perhaps one of the last.

**It must have been a strange experience to talk *tête à tête* with Brouwer.**

*It was.* And of course he was killed suddenly and so I was left feeling a fool for not having made the best of my amazing good fortune, to be someone he was happy to talk with, and there were very few at that period of his life.

**I notice you seem to play down the enormous influence of Constructivism and Neo-Plasticism, choosing more 'private' artists, Picabia, Kupka, Duchamp and Vantongerloo.**

All of that is substantially true. I feel that I *knew* the 'four'; the others I may have invented in my imagination. I *can't* imagine a conversation with Malevich or Tatlin, or with Mondrian for that matter.

**Amongst the living constructivist artists of your time, what contact did you have with Gabo?**

I liked Gabo very much, but he was blighted with the emigré syndrome and even at times seemed a little paranoid. I never met his brother Pevsner but I used to meet some of the other Russians in Paris . . . . Annenkov, and I first met Mansourof at Sonia Delaunay's and later in his studio in Montparnasse.

**Aside from this, you also had contact with other veteran survivors of *De Stijl?* What about Domela for example?**

A remarkable man, so strong and active for 83. It is quite amazing and one completely forgets his age. I like his work but for reasons which he thinks are insulting. For me his work is the triumph of High Art Deco.

**You've mixed a bit with some of the 'triumphant' Americans, Sam Francis, Ad Reinhardt and others. Have they had any impact on your life and work?**

I retain a nostalgic affection for Sam Francis and the paintings he made in the 'fifties. Ad Reinhardt I met in New York. We were speakers at a symposium on geometry and art arranged by the Anonyma Group in 1964 (Ernst Benkert, Frank Hewitt and Ed Mieczkowski). Later he came to my studio and we talked about Mondrian and symmetry. We visited the Kline exhibition at the Whitechapel — which he didn't much care for — he was a striking personality, something like a mixture of Norman Mailer and a Zen adept.

**What about the Minimalists?**

They were too 'rogue elephant' for my taste . . . Barnett Newman re-done in industrial materials. From that generation Kenneth Snelson emerged as an artist I very much admire; something quite different and certainly the only American *Constructivist* in the best technical sense of the word.

*AFTER RODCHENKO CONSTRUCTION OF DISTANCE 1920,* 1968
Anodysed aluminium

**Do you regard Biederman as a maverick artist in the best sense of that term?**

Oh yes, absolutely. Biederman made his stand in 1948 and I still feel that the artists of the first half of the century made better and more honest art. But of course, the American contribution there is small and sometimes too ambitious; think of Morgan Russell and MacDonald- Wright! For me Walt Disney is one of the most important American visual artists. For the rest the best talent emerged in architecture and went on for some time.

***One* of the great moments as far as your interests are concerned must have been the short flourishing of the Formalists in Soviet Russia?**

Yes, I wish Roman Jacobson would publish his autobiography and we could read him at greater length on that period. One can trace the Structuralism written about today to the Linguistic Circles which grew originally alongside creative artists in those tumultuous years.

*January 1983*

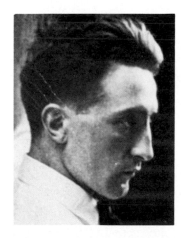

Marcel Duchamp

Francis Picabia

Frank Kupka

Georges Vantongerloo

## Yona Friedman:

I first met Anthony Hill more than 20 years ago. I only knew at that time he is a sculptor but did not know his works.

What impressed me, was his inquisitive mind, his keen eye seeing the structures behind the facade of things, and his particular talent to discover the aesthetic quality in structures. When, somewhat later, I saw his works, this confirmed the picture I had made about his personality.

Anthony Hill is a 'discoverer-artist'. Each work of his is an act of discovery, either of an abstract mathematical structure (which he succeeds to translate into an artwork) or of an aesthetic structure (which he transposes into graph theory).

In order to understand his oeuvre, one should not look at only one of its aspects (structure or aesthetics). The real value of what he creates comes from its 'bi-lingual' quality. Imagine poetry, written in two distinct languages at the same time and which you read in one or other of the languages without losing its quality.

Anthony Hill c.1955
Photo: Ida Kar

## Frank Harary:

Two decades ago, Anthony Hill visited on my first arrival at University College London, to present his conjectured solution to the 'crossing problem' and his novel idea of the rectilinear crossing number of a non-planar graph.

After many delightful discussions, I was able to recast his abstract artistic architectural thinking into a mathematical mould. This joint paper became his first published article in the mathematical research literature. Subsequently he has authored or co-authored eleven additional research works in graph theory. Surely enough for a lectureship in mathematics if he held the academic union card known as the PhD degree!

Anthony Hill 1976
Photo: Jérome Ducrot

## John Myhill:

In an article in *Leonardo* (1968) Anthony Hill investigated Mondrian from the point of view of topological asymmetry (most Mondrianologists want to do number magic on the artist's metrical properties — Golden Mean etc.), this interested Hill not at all, he's interested in *connection* not measurement. *Size* is for him an 'artistic' decision, *topology* is prior to artistic decisions, defining the framework within which they are made.

If Webern had colours they would be earth colours, fallen leaf colours, not pristine black and white, (of course *that's* an oversimplification because black and white are never pristine, they reflect, they catch glints, they throw shadows in different ways from different angles etc.). What we should say is that Webern's tone colours have a *grain,* that whatever his epigones may have done with machines, his pieces are and must be played by living *breathing* human beings. Breath = brush-stroke or grain, and brushwork is what Anthony Hill conspicuously avoids.

With one of Hill's works you can hold it still, look at it for a while and suddenly you can see what's going on — this is more difficult in a piece of serial music — you see it quite unexpectedly when you'd almost given up and you say "Oh, there are all the arrangements of nine Thingumi-Bobs in groups of three doo-da's" and there is a nice aesthetic frisson when this happens. (And still he placed them *so* and *so,* and *so;* and was *that* an Artistic Decision, or is that permutational too?) That's what enables him to get away without any sensory appeal.

*Three extracts from "Thoughts on Anthony Hill and Webern".

## MATHEMATICAL BIOGRAPHY

**1950**
Beginning of renewed mathematical consciousness.
**1952**
Attended lectures by Imre Lakotos at the London School of Economics ('Proofs and Refutations').
**1958**
Commenced work on the crossing number of the complete graph – hitherto unpublished problem – embarked on collaboration with John Ernest leading to conjecture.
**1959**
First visit to L E J Brouwer.
**1963**
Publication with Frank Harary of *On the number of crossings of the complete graph.*
**1968**
Publication of results in study of Mondrian's compositions, in *DATA* and *Leonardo*.
**1969**
Contacted by Frieder Nake. Commenced joint collaboration on Mondrian studies.
**1970**
Awarded Leverhulme Fellowship and was elected Honorary Research Fellow in the Department of Mathematics, University College, London.
Invited speaker at the International Conference on combinatorial mathematics, New York Academy of Sciences.

**1973**
Visit to the Department of Mathematics in the universities of Montreal, Calgary, Buffalo (SUNY) and the Bell Telephone Labs. Speaker at British Combinatorics conference, Aberystwyth.
**1974**
Talks given at Maths Department, Polytechnic of the South Bank, University of Oxford, Birkbeck College (Dept. Physics) and CSAV Prague.
**1975**
Talks at Chelsea College (Dept. of Philosophy and History of Science) 5th BCC Aberdeen, Charles University Prague and Institute of Mathematics, Bucharest.
**1976**
Invited speaker at CNRS conference 'Problems Combinatoire et theories des Graphs' Orsay.
**1977**
Frieder Nake published joint Mondrian researches in 'Asthetik als Informations – Verarbertung' Springer-Verlag, Wien New York.
**1979**
Elected member of the London Mathematical Society and made visiting research associate in the Department of Mathematics, University College, London.
**1981**
L E J Brouwer – Centenary Conference Nordowijkerhout. Contributed paper.

## SOME MATHEMATICAL MENTORS:

C A B Smith. C A Rogers. W O J Moser. Frank Harary. Richard Guy. Lowell Bieneke. H S M Coxeter. R O Davies. Sandy Balaban. Karel Culick. Lou Quintas. Claude Berge. David Singmaster. J E Reeve. Ronald Foster. Peter Mani. Miroslav Fiedler. A Gewirtz. Z Hedrlin. E Jucovic. David Bohm.

Above: L E J Brouwer
Left: Roberto Frucht
Right: John Myhill

## MATHEMATICAL PAPERS

1. 'On the number of crossings in a complete graph'. F. Harary & A. Hill in *Proc. Ed. Math. Soc. vol.13 Dec. 1963*

2. 'On Certain Polyhedra'. A. Hawkins, A. Hill, J. Reeve, J. Tyrrell *Math. Gazette vol.1 May 1966*

3. 'Cubic identity graphs & planer graphs derived from trees'. A. Balaban, R. Davies, F. Harary, A. Hill & R. Westwick. J. Aust. *Math. Soc. vol.11 1970*

4. 'El numero minimo de puntas para grafos regulares y asimetricos'. A. Gewirtz, A. Hill & L. Quintas *Scientia No.138 1969*

5. 'External problems concerning graphs & their groups'. A. Gewirtz, A. Hill, L. Quintas *Proc. Calgary Graph Theory Conf. 1969*

6. 'Some problems from the visual arts'. A. Hill *Int. Con. Comb. Math. Ann. N.Y. Acad. Sciences July 1970*

7. 'On the crossing number of the complement of a circuit'. R. Guy, A. Hill *Discrete Mathematics vol.5 No.4 Aug. 73*

8. 'Graphs with Homeomorphically irreducible spanning trees' *London Mathematical Society : Lecture Notes 13*
'Combinatorics' *Proceedings of the British Combinatorial Conference 1973 Cambridge University Press, 1974*

9. Some topics in 3-polyhedral graphs *Recent Advances in Graph Theory Symposium CSAV Prague 1974*

10. 'Some class of Hamiltonian 3-polytopes'. David Singmaster & A.Hill. *Proceedings of the Fifth British Combinatorial Conference University of Aberdeen, July 1975*

11. 'Labled & unlabled Hamiltonian Circuits in a class of 3 polytopes'. A.Hill & David Singmaster. *Same conference*

12. 'The continuous charms of discrete mathematics — some grassroot problems in Ars Combinatoria'. *Colloques Internationaux du C.N.R.S.*
'Problems Combinatoires et Théorie des graphs'. *Orsay July 1976*

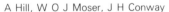

A Hill, W O J Moser, J H Conway